The College History Series

TUSCULUM COLLEGE
TENNESSEE

The College History Series

TUSCULUM COLLEGE
TENNESSEE

FRANK T. WHEELER

ARCADIA
PUBLISHING

Published by Arcadia Publishing
Charleston, South Carolina

Printed in the United States of America

Library of Congress Catalog Card Number: 00-105331

For all general information contact Arcadia Publishing at:
Telephone 843-853-2070
Fax 843-853-0044
E-Mail sales@arcadiapublishing.com
For customer service and orders:
Toll-Free 1-888-313-2665

Visit us on the Internet at www.arcadiapublishing.com

Dedication

This book is dedicated to the alumni of Tusculum College.
I hope that as you thumb through the pages you are
reminded of your days on campus.

CONTENTS

ACKNOWLEDGMENTS

First and foremost I want to thank Cindy Lucas and Alvin Gerhardt. Their tireless efforts in the Doak House Museum and the Andrew Johnson Museum and Library are a testimony to their professionalism and love of saving history. Tusculum College owes them a debt of gratitude.

I would be remiss not to recognize the authors of works on Tusculum more scholarly than the one you are about to read. Allen E. Ragan's *A History of Tusculum College, 1794–1944* laid the foundation from which all other works must stand. *The Life and Times of Tusculum College*, by Joseph T. Fuhrmann, brought the recorded history of the college into the 1980s. Lastly, *Glimpses of Tusculum College: A Pictorial History*, co-authored by Donal J. Sexton Jr. and Myron J. "Jack" Smith Jr., written in celebration of Tusculum's bicentennial in 1994, combines scholarly work with a pictorial history to appeal to a wide audience. Gentlemen, thank you for all that you have done to record the history of Tusculum College.

Finally I want to thank the alumni of Tusculum College. As I travel throughout the country visiting with you I am told many wonderful stories about your days on campus. Hearing these stories led me to embark on this project.

INTRODUCTION

In 1794, George Washington was president of a young country and the state of Tennessee was still two years away from becoming a reality. In what is now East Tennessee, Hezekiah Balch and Samuel Doak, Presbyterian ministers educated at the College of New Jersey (now Princeton University), were ministering to the pioneers of what was the southwestern frontier of the United States. They also knew that the educational needs of these Scotch-Irish settlers must be addressed. Doak and Balch, although they did not always see eye to eye, were visionaries ultimately seeking the same goals through the rival colleges they established. They wanted to educate settlers of the American frontier so that they would become better Presbyterians, which in their minds, made them better citizens.

The rich heritage of Tusculum College descends from two schools. The first, Greeneville College, was chartered in September 1794 by the General Assembly of the Territory of the United States South of the Ohio River, and established by Hezekiah Balch. The second, Tusculum College, founded as an academy in 1818 by Samuel Doak and his son Samuel Witherspoon Doak, merged with Greeneville College in 1868 to form Greeneville and Tusculum College. In 1908, Greeneville and Tusculum College merged with Washington College, creating Washington and Tusculum College. This union dissolved in 1912 and thus evolved modern-day Tusculum College.

The early history of the college is closely linked to the early history of the American frontier. As the pioneer settlers thrived, so did the college. As the area was torn apart during the Civil War, so were the two institutions that would later merge. But, like the pioneers who settled the region, the college survived. It survived financial difficulty and near disastrous enrollment droughts during World War I and World War II. It survived the Civil War due to the merger of the two institutions. The college survived these devastating events only to bounce back stronger than before.

There are many people who played important roles in the development of the institution. It is difficult to guess what Tusculum College would be like today without early influences such as Charles Coffin, Cyrus and Nettie McCormick, Charles Oliver Gray, Landon Carter "Daddy" Haynes, and a host of others too numerous to mention individually. Of all of these people, Nettie Fowler McCormick undoubtedly had the largest impact on the college. The look of the campus would be entirely different if it

had not been for her generosity in the construction and furnishing of a large number of the buildings on campus. Her generosity, over several decades, encouraged the growth of the campus in a variety of ways.

Tusculum College is the oldest college in Tennessee and the 28th oldest in the nation. In addition, Tusculum is the oldest coeducational institution affiliated with the Presbyterian Church (U.S.A.) and an early national pioneer in the admission of women. Even though its relationship with the Presbyterian Church and its influence on students has changed dramatically over the past 200-plus years, Tusculum College has always valued its relationship with the Presbyterian Church. Remembering the college's Presbyterian roots is critical for current and future generations of Tusculum students as they strive to understand how the institution they know came into being.

The pages of this book are filled with historic photographs from the archives at Tusculum College, and the accompanying captions were compiled using information found in the other written works on the college, the archives, yearbooks, student newspapers, and, most importantly, the recollections of alumni and friends of Tusculum. These individual reminiscences provide the personal side of an institution, thereby shaping its identity.

One

THE FIRST SEVENTY YEARS

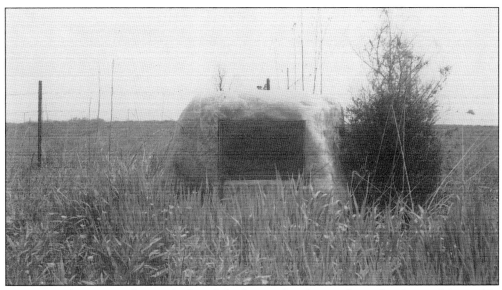

On September 3, 1794, Hezekiah Balch obtained a charter from the General Assembly of the Territory of the United States South of the Ohio River for the establishment of Greeneville College. He founded the college on land he had purchased on Richland Creek south of Greeneville. This stone marker is 3 miles south of the intersection of Crescent and South Main Street (Old Asheville Highway). The marker reads, "Site of Greeneville College, Chartered September 3, 1794, Merged 1868 With Tusculum College, Erected by Tusculum College and Nolachuckey Chapter D.A.R., 1940. Exact site by trees on hill." Hezekiah Balch was a graduate of the College of New Jersey (now Princeton University) and was called to Mount Bethel Church in Greeneville in 1783.

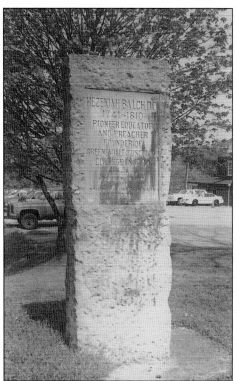

During the first meeting of the college trustees, held on February 18, 1795, in the Greeneville home of James Stinson, Hezekiah Balch was chosen as the first president of the college. On August 16, 1796, a building committee was instructed to contract for the erection of a building on the site near Balch's home. It was to be frame, 32 by 26 feet and two stories high, with a chimney on each end. The building was in use by 1805. Balch died in April 1810 and is buried in Harmony Graveyard in Greeneville. In 1839, the school was moved to the Rhea Academy building in Greeneville while the board tried to secure a new home.

Charles Coffin was elected president on April 27, 1810, following Hezekiah Balch's death. He had been elected vice president of the college on January 9, 1801, with the authority to obtain donations. Coffin died June 3, 1853, and is buried in Harmony Graveyard next to Hezekiah Balch.

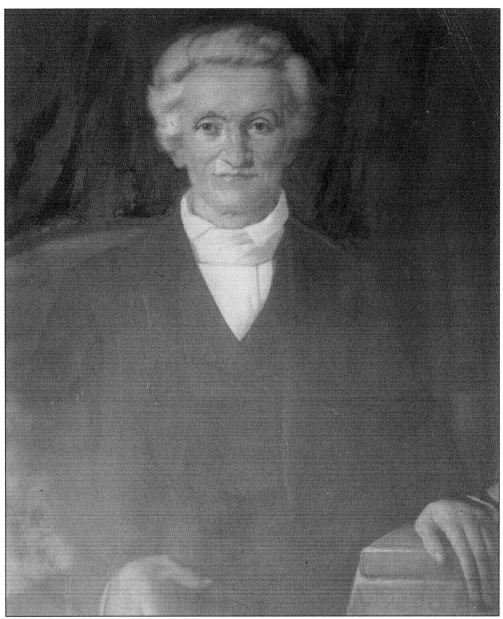

In October 1826, Pryor Lee, a former Greeneville College student and secretary of the board of trustees of East Tennessee College in Knoxville, approached Coffin (pictured here) about the presidency of that institution. He also proposed to Coffin the merger of the two institutions. Coffin was receptive to both the presidency and the merger, but the Greeneville College trustees voted down the latter. The proposed school would have been in Knoxville and the Greeneville College buildings would be used as a female academy. The trustees had already attempted in 1812 and 1813 to have the College of East Tennessee placed in Greeneville, and in 1822, East Tennessee offered a merger. Nothing ever became of these proposals. On April 23, 1827, Coffin resigned to assume the presidency of East Tennessee College, now the University of Tennessee.

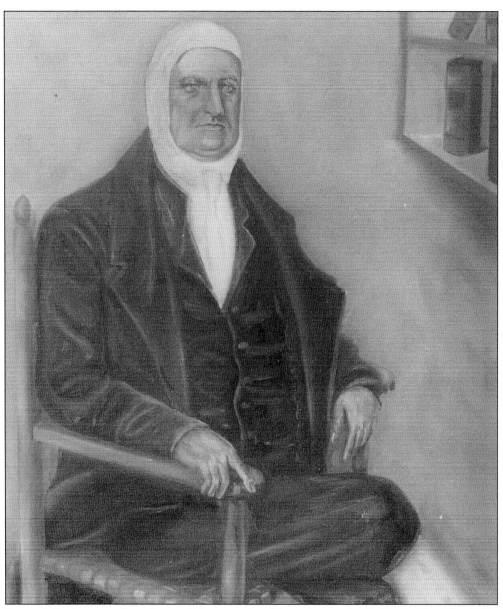

Samuel Doak was referred to as "the apostle of learning and religion in the West." He was born on August 1, 1749, entered the College of New Jersey in 1773, and graduated in 1775. Doak felt he was most needed in the West and, in 1780, found himself in the area that would become Tennessee. According to the minutes of the General Assembly, Doak formed the Salem congregation in 1780. In 1784, Doak received a charter from the state of North Carolina for Martin Academy, and in July 1795, it was chartered as Washington College. The first two graduates of Washington College (1796) were John Whitefield Doak and James Witherspoon. Samuel Doak served as president until his resignation in 1818. Upon his resignation he moved to Greene County where he and his second son, Samuel Witherspoon Doak, founded Tusculum Academy. Samuel Doak died on December 12, either 1829 or 1830, and is buried in the cemetery at Washington College.

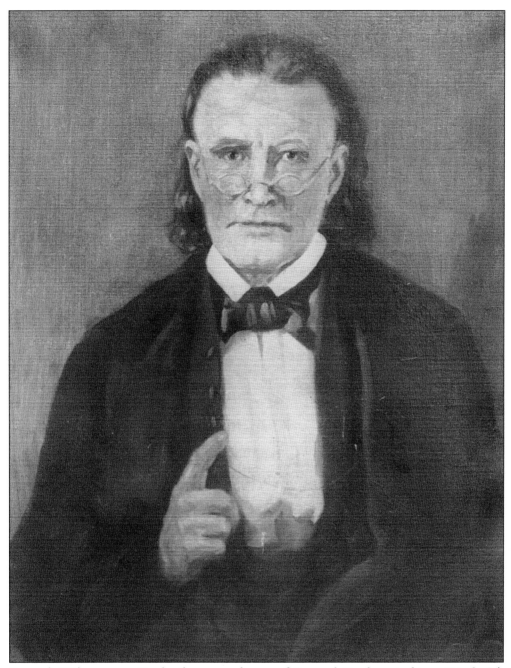

Samuel Witherspoon Doak, the second son of Samuel Doak, was born March 24, 1785. He graduated from Washington College in 1806 and was licensed by Abingdon Presbytery on October 10, 1809. Doak left for Philadelphia where he remained for four years before returning to East Tennessee in 1813 and preaching at Mt. Bethel and Providence Churches. He served as vice president under his father at Washington College and briefly served as that institution's president, from 1838 to 1839. As a minister and an educator he ranked high among the fathers of the synod. He died February 3, 1864.

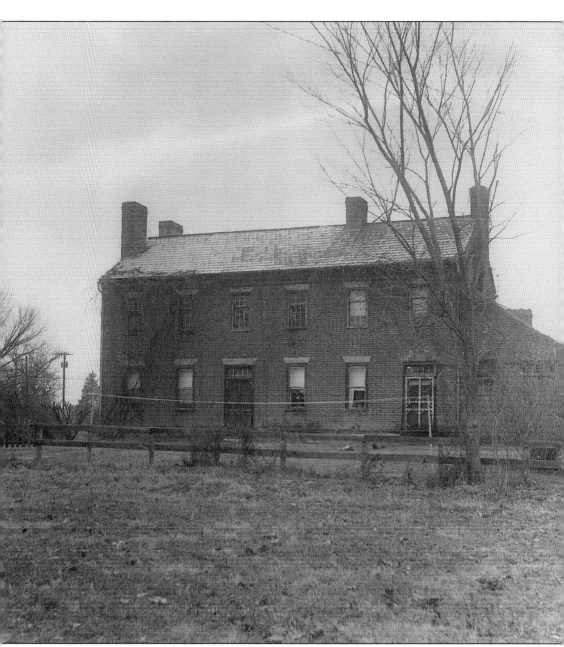

Tusculum Academy, opened in 1818, was operated in the Doak House (pictured above). Samuel Doak resigned as president of Washington College and moved with his son, Samuel Witherspoon Doak, to the present site of Tusculum College and opened the school. Legend has it that the name "Tusculum" comes from the home of President Witherspoon of the College of New Jersey (now Princeton), which was named for Cicero's villa outside of Rome. Tusculum Academy was incorporated by the legislature on February 1, 1842, and in 1844, the legislature changed the name to Tusculum College. The Academy was suspended upon the death of Samuel Doak. In 1835, Samuel Witherspoon Doak reopened the school with four students. By 1840, there were 70 students and the need for a new building.

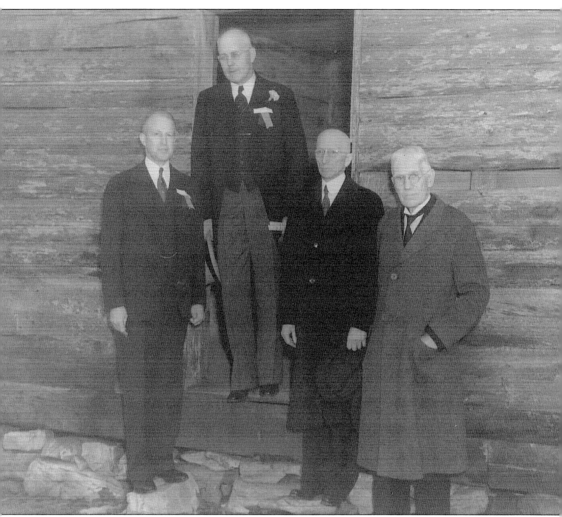

Tusculum Academy consisted of several buildings around the Doak House. Pictured here are President Charles Anderson (left), Jere Moore (second from right), and Landon Carter "Daddy" Haynes (right) outside what is probably the academy building. By 1840, Tusculum Academy was in desperate need of new facilities. This photo was taken in the 1930s.

Old College, pictured here in 1914, was built in 1841. Legend has it that Samuel Witherspoon Doak's slaves fired the bricks near the site, and he promised to give them their freedom upon completion of the project. Old College measured 30 by 60 feet and allowed space for a chapel, classrooms, literary societies, and a library. Students lived with families in the area, and later shacks were built to house some of the boys.

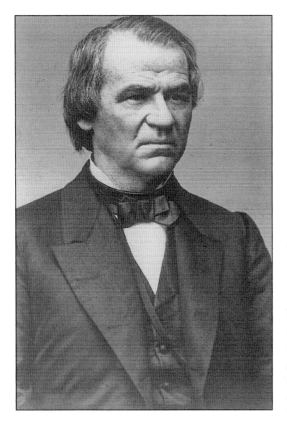

In December 1993, renovation began on Old College, and it was turned into the Andrew Johnson Presidential Library and college special collections, including the Coffin Collection. Johnson served as a trustee at Tusculum College and is credited with contributing the first $20 for the construction of Old College. Margaret Johnson Patterson Bartlett, great-granddaughter of President Andrew Johnson, donated the bulk of the Andrew Johnson Collection in 1980.

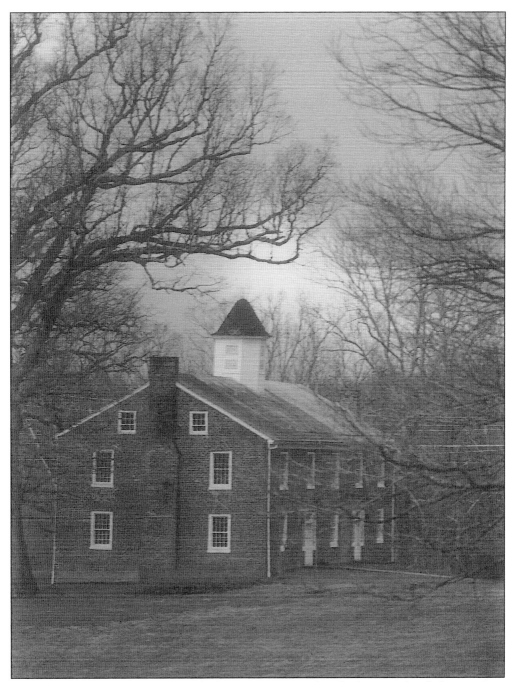

Following the Civil War the board of trustees reported, "The late war has left Tusculum College in a deplorable condition - its enclosures are broken down, its library much wasted and abused and its chemical and philosophical apparatus broken and destroyed." Greeneville College was in a similar situation. In February 1866, a committee of three from the Greeneville College Board of Trustees met with an agent from the Freedmen's Bureau to discuss leasing the college building for a school for blacks, but this never occurred. Pictured here is Old College.

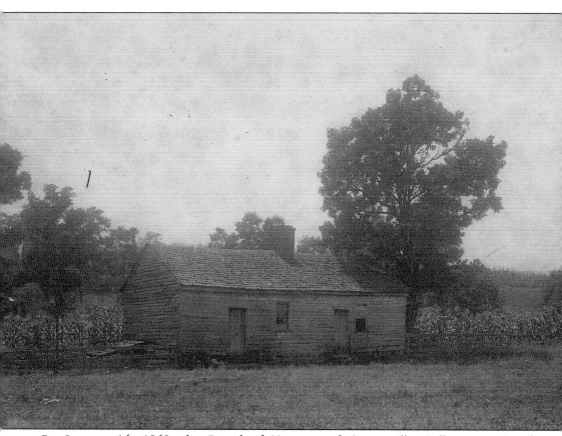

On January 16, 1868, the Board of Trustees of Greeneville College appointed a committee to negotiate with a similar committee from Tusculum College to consider consolidation. President William B. Rankin of Greeneville College and the board of trustees had decided that Greeneville College could no longer operate independently. The consolidation took place in 1868, the name was changed to Greeneville and Tusculum College, and the institution occupied the Tusculum College campus. The Greeneville College site was so badly damaged by the war that it was sold for $700 and the remaining library material was moved to Tusculum. Pictured here is the second Tusculum Academy building.

Two

GREENEVILLE AND
TUSCULUM COLLEGE

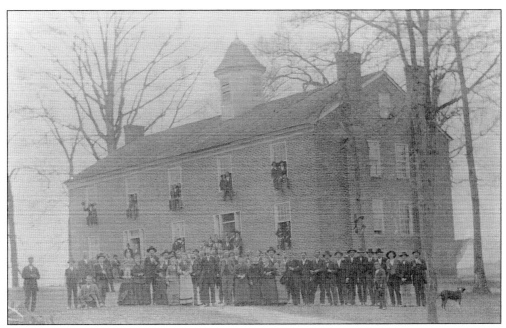

The first graduates from Greeneville and Tusculum College were R.M. Dobson and A.S.N. Dobson. They had been students at the start of the Civil War but were unable to take their final examinations. They received their degrees in December 1868. The first woman to graduate from Greeneville and Tusculum College was Julia Doak, who received her degree in 1879. This photograph of Old College was taken in 1878.

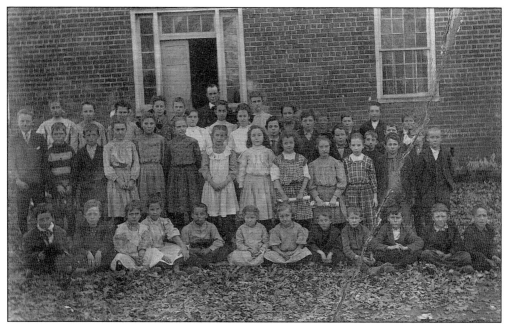

Greeneville and Tusculum College operated a primary department for which the 1876 tuition was $1.25 per month. At this point, the school year was only eight months long. During the 1878–1879 school year there were 32 students enrolled in the primary department. In 1904, students entering the academy were required to have a reasonable knowledge of reading, writing, spelling, primary geography, arithmetic, and elementary English grammar. This photograph was taken *c.* 1908.

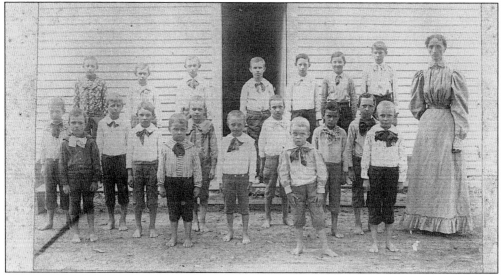

The 1901–1902 catalog stated, "The aim of the Academy is to furnish a thorough preparation for entrance to the college. The course of instruction is based on the requirements for entrance examinations for colleges and universities. The Academy also furnishes an excellent high school course for those who do not intend to take a complete college education. If followed by our one year of Normal Studies, it affords an excellent equipment for teachers in our public schools."

The Greeneville and Tusculum College Class of 1894 (pictured here) attended the college during the presidency of Jere Moore, which lasted from 1883 to 1901. In the academic year 1890–1891, the student body reached 184 with 42 of those attending the college and the remainder in the academy. Enrollment suffered greatly during the depression of the 1890s.

Pictured here are voice students from 1901. There was an increased emphasis in both vocal and instrumental music after 1891. Samuel Coile succeeded Jere Moore as president in May 1901. A member of the Class of 1879, he attended Lane and McCormick Seminaries and had been a part of the group of students who influenced Cyrus and Nettie McCormick's interest in the college. Coile served as president until July 1907.

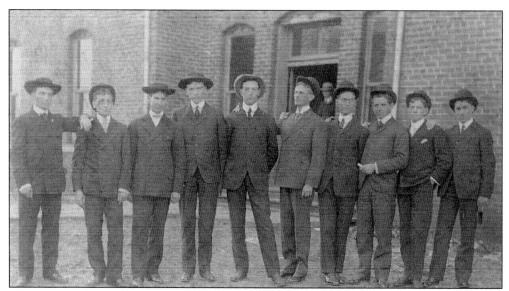

After the establishment of Greeneville and Tusculum College, baseball was forbidden because it was believed that it interfered with studies. This ban was eventually lifted; however, the conduct of every student must accord with Biblical rules of morality: "Violation of the Sabbath, habitual indolence, lounging about public places, and the use of intoxicating liquors as a beverage, will be regarded as grave offenses." This photo was taken during academic year 1902–1903.

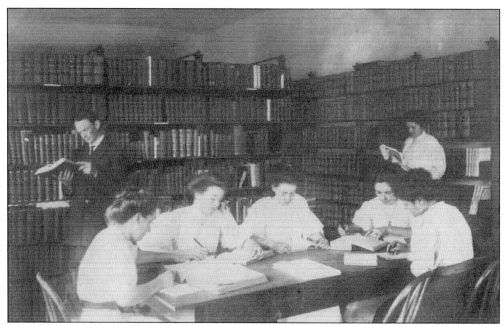

Pictured here is the college library, which was located in McCormick Hall from the time of its construction until the completion of the Carnegie Library. Changes in the curriculum, starting in 1891, allowed women to substitute French and German for Greek.

The 1901–1902 catalog stated that uniforms were suggested but not required. The uniform for women consisted of a navy blue dress and mortarboard cap with "G and T" in gilt on the front. Shirtwaists were allowed in season. Men were required to wear a fatigue uniform of cadet gray with black trimmings. This picture was taken during the academic year 1902–1903.

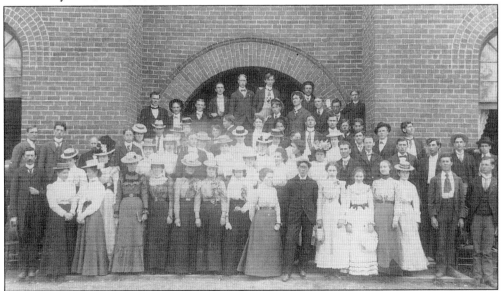

During the presidential administration of Samuel Coile, the teaching load was primarily carried by three men. Coile taught mental and moral science, Thomas S. Rankin taught Latin, and Landon Carter Haynes, also known as "Daddy Haynes," taught mathematics and physical science. This photograph was probably taken during a commencement celebration in the early 20th century.

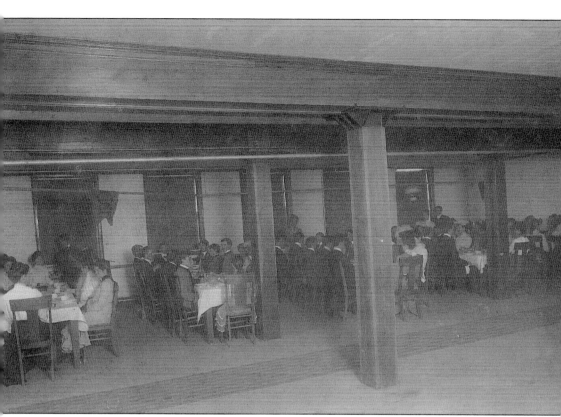

Greeneville and Tusculum College began negotiating a merger with Washington College in 1878. In May 1884, Greeneville and Tusculum College proposed that each institution continue raising funds and that the school gaining the most contributions would choose which institution would be a college and which would be an academy. These conditions were not accepted and the merger idea was shelved for several years. Pictured here is the dining hall in the basement of Virginia Hall. Note the pennant in the left side of the image with the "G and T" for Greeneville and Tusculum College.

Three

WASHINGTON AND TUSCULUM COLLEGE

On May 15, 1908, after many attempts to merge Washington College and Greeneville and Tusculum College, the Board of Trustees of Greeneville and Tusculum College voted to approve a merger. Thomas S. Rankin, secretary and treasurer of the board of trustees, wrote in the minutes, "And thus the two noble institutions which for over a century had been working side by side, joined hands, merged their interests, and turned, I trust, toward a future of even greater usefulness. May the richest benedictions of Almighty God rest upon the united institution!"

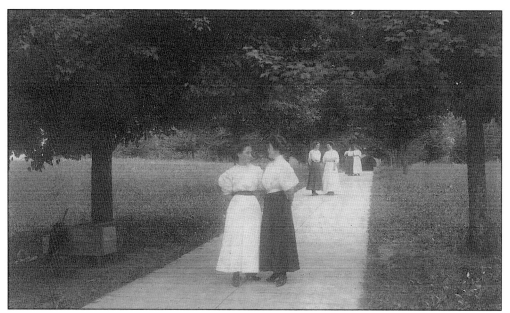

The merger established that the Washington College campus house the academy and the agricultural and industrial work. The Greeneville and Tusculum College campus housed the traditional academic work and the domestic science program, and the new name of the college was Washington and Tusculum College. Pictured here is "The Promenade" on the Tusculum campus, *c.* 1908.

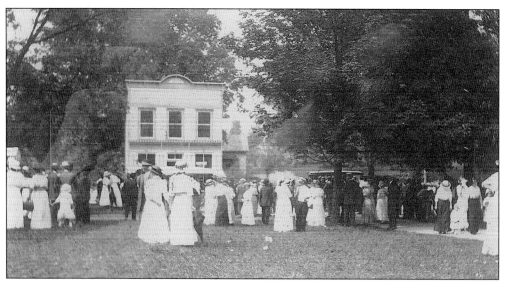

The Reverend Charles Oliver Gray was elected president in 1908. He came to East Tennessee as president of both institutions and was not pleased with the prospect of dissolving the Tusculum Academy. Pictured here is a crowd on campus for commencement, *c.* 1910. The building in the background is Dobson's Store, a local business.

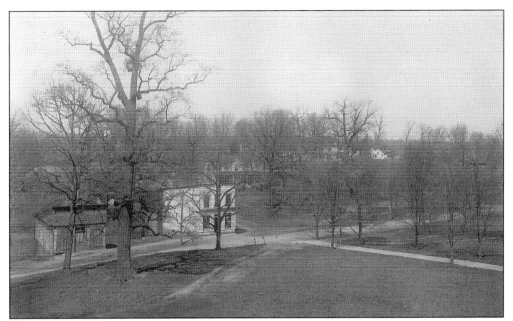

It was believed that for the academic program on the Tusculum College campus to be successful the school needed a preparatory department. Most of the students arriving at the college needed preparatory work. This view is from the bell tower of McCormick Hall, looking toward the President's House.

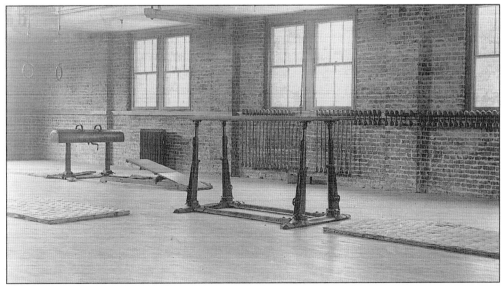

One issue facing the college was the need for a new library. Andrew Carnegie contributed $21,000 for the construction of a library at Washington and Tusculum College, and President Gray received permission from Carnegie to divide the funds and add it to money raised to build a library on each campus. The library on the Tusculum campus also included a gymnasium (pictured here) and two classrooms.

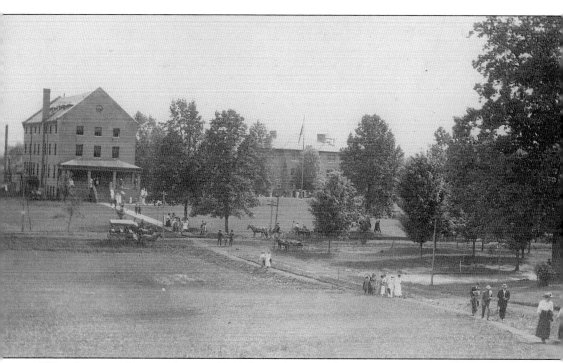

This photograph was taken in 1911 from the President's House. Pictured are Virginia Hall and McCormick Hall.

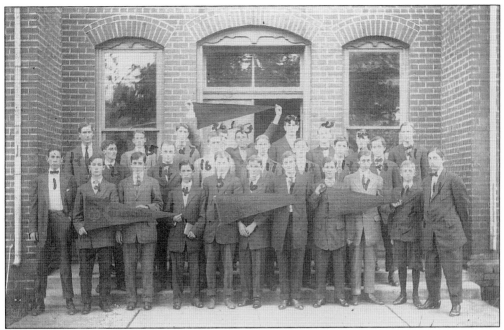

This photograph was taken on November 15, 1910, in front of Craig Hall. The catalog for that year stated, "Young men may call on friends in the reception room of the Girl's dormitory, walk on the campus, or play tennis together each Monday afternoon from 1 to 4, also each day from the end of the noon meal until 1. Aside from this young men and women shall keep entirely separate except with special permission."

Before a water system was installed, students had to follow this path to the spring. In the 1941 *Tusculana*, the college yearbook, the Doak Spring House was listed as a "forbidden place for couples."

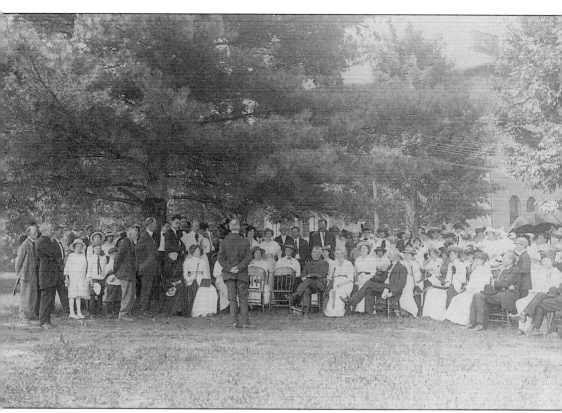

Since Tusculum refused to dissolve its academy, and for a variety of other reasons, a group of trustees living near Washington College began a movement in 1911 to dissolve the union. They felt that the agreement had been violated and won a case that went to the Tennessee Supreme Court dissolving the union based on the fact that the Washington College trustees did not have a unanimous vote in 1908. On November 23, 1912, the schools were ordered to return to their former status, and they did so immediately. Pictured here is President Charles Oliver Gray speaking to a crowd probably gathered during a commencement.

The captain of the 1908 football team is the subject of this photograph. His team played five games and only the results of three of those are known today. Of those three games, Washington and Tusculum College lost two and tied one.

The area in front of McCormick Hall is pictured in March 1911.

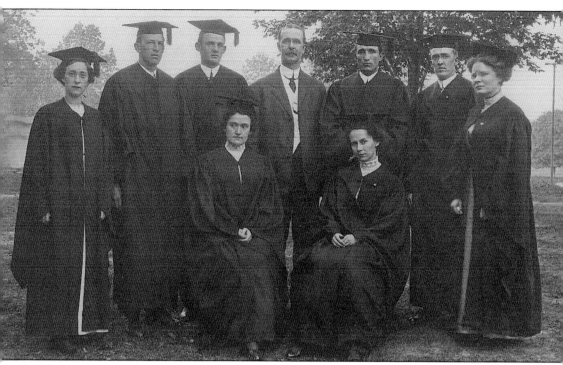

The Class of 1912 (pictured here) has the distinction of being the last graduating class of Washington and Tusculum College. The 1912–1913 catalog said of the break-up of Washington and Tusculum College, "For four years the union was supposed to be valid, but in December last the Supreme Court declared that the union had not been legally consummated. This restored Greeneville and Tusculum College to its former identity. At once the corporate name was changed to Tusculum College, and a new and brighter future dawned for the historic institution."

Four

NETTIE FOWLER McCORMICK

Nettie Fowler McCormick has had, without a doubt, the most profound influence on the development of Tusculum College. Her husband, Cyrus McCormick, was drawn to Tusculum through four young graduates who were attending the McCormick Theological Seminary in Chicago. Cyrus McCormick was the inventor of the mechanized reaper and established the company known today as International Harvester. Cyrus died not long after visiting Tusculum, but knowing his desire to support the college, his wife continued with his wishes.

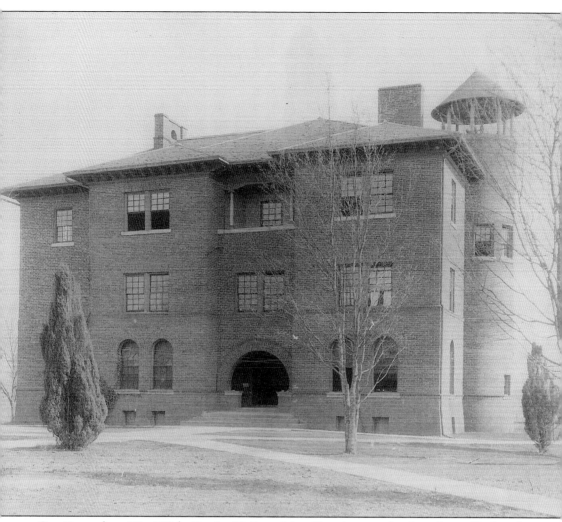

On November 21, 1884, Nettie McCormick offered to make her first gift for the construction of a new building. She offered to contribute $7,000 under the conditions that Greeneville and Tusculum College raise $4,000, that the president and at least two professors shall be members of the Presbyterian Church, and that the president of the board and two thirds of its members also be members of the Presbyterian Church. Upon any violation of this the $7,000 was to be returned to the Board of Aid of the Presbyterian Church (U.S.A.). The funds were raised and the cost of construction and furnishings totaled $13,000. McCormick provided $84,000. The building named McCormick Hall housed offices, classrooms, the library, and the chapel. The 1908 catalog stated that there were 8,500 volumes in the library in McCormick Hall.

The McCormicks were drawn to Tusculum for two primary reasons—Calvinist orthodoxy and political reconstruction. The McCormicks believed in a strict Calvinistic interpretation of Presbyterian doctrine, with the notions of predestination and salvation of the elect, and therefore established the McCormick Theological Seminary in Chicago. The McCormicks were also concerned with preserving the union and a re-merging of the Northern and Southern Presbyterian churches following the Civil War. Due to the strong Unionist sentiments in East Tennessee, the McCormicks felt the desire to support education in the area.

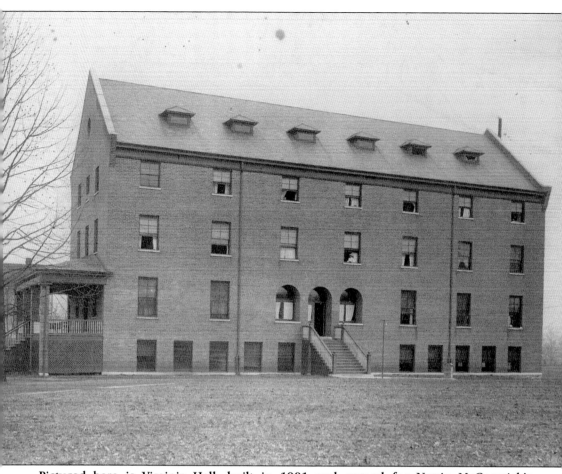

Pictured here is Virginia Hall, built in 1901 and named for Nettie McCormick's daughter. Virginia Hall was one of two buildings on campus designed by Louis Sullivan, the architect famous for coining the phrase "Form follows function." The 1901–1902 catalog states, "Virginia Hall contains domestic science halls, reception hall, parlor, art studio, gymnasium, student rooms, bathrooms on every floor with hot and cold water lavatory etc. Abundant provisions were made against fire . . . each floor being equipped with water connection, hose, and fire escapes." Virginia Hall was used for many years as a girl's dormitory.

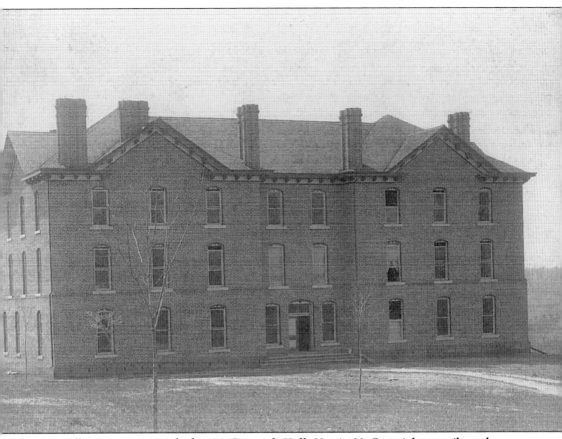

Craig Hall was constructed after McCormick Hall. Nettie McCormick contributed over half of the funding for the building, which was completed in the fall of 1892 at a cost of $8,355.96 and housed 72 men. The three-story brick building was named for Rev. Willis G. Craig, D.D., of Chicago, who was responsible for introducing the McCormicks to Tusculum. Dr. Craig introduced George Baxter, John R. Gass, and Alexander and Samuel Coile to the McCormicks. At one time, the dining hall was in what is now the lobby of Craig Hall. Today the dormitory is known as Welty-Craig Hall.

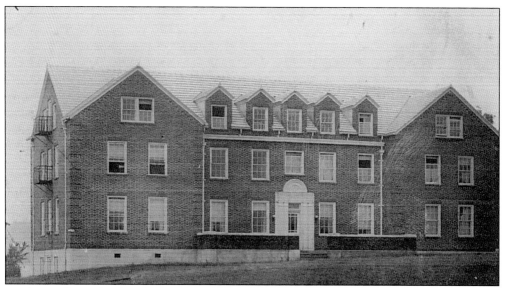

Rankin Hall was built in 1923 and originally named Gordon Hall for Mrs. McCormick's son. The name was changed in the 1950s to honor a longtime Tusculum professor, Thomas Samuel Rankin. Rankin Hall was the last building constructed at Tusculum with the financial assistance of Nettie McCormick. The dormitory originally housed 46 students and one teacher.

When Charles Oliver Gray arrived on campus in the fall of 1908, Tusculum College was in desperate need of a president's residence. The Grays lived in Virginia Hall with their youngest son while their two oldest sons lived in Craig Hall. In 1909, through the generosity of Nettie McCormick, 14 acres were purchased across the unpaved road from the campus. Here the college constructed the president's home, water tower, and two homes for faculty.

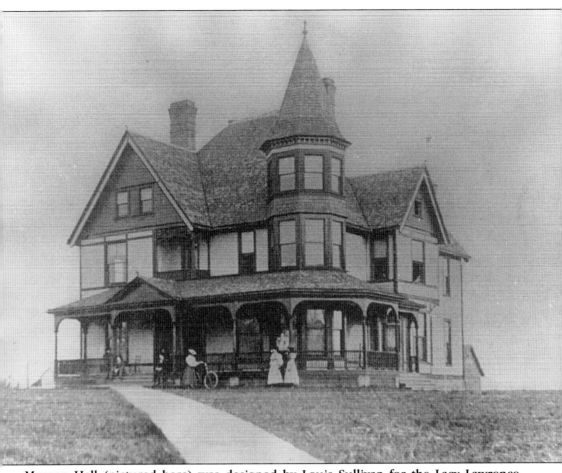

Morgan Hall (pictured here) was designed by Louis Sullivan for the Lacy Lawrence family. Tusculum College purchased the home and remodeled it to house 25 students. It was named in honor of O.K. Morgan, a college trustee. Morgan Hall was demolished in the 1960s to make way for the construction of the Annie Hogan Byrd Fine Arts–Chapel.

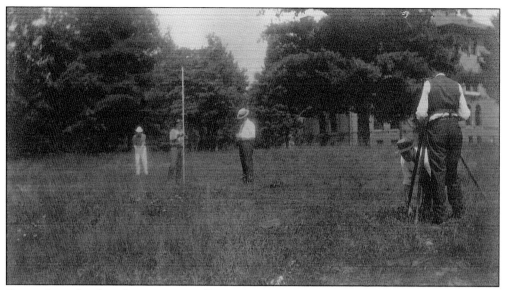

Ground was broken for Haynes Hall on commencement weekend, 1914. It was named for the very popular professor Landon Carter "Daddy" Haynes, cost just over $30,000 to build, and originally served as a women's dormitory. This photograph shows the surveying for the building.

Haynes Hall also housed a student infirmary and Mrs. McCormick's much-loved domestic science department. This building is three stories and has a full basement. The name of the Chicago architect who built Haynes Hall is unknown.

Five

ACADEMICS, CLASSES, AND FACULTY

Pictured here is President Charles Oliver Gray leading the 1930 commencement procession. The first recorded degree given at Greeneville College was given to Hugh Brown in 1808.

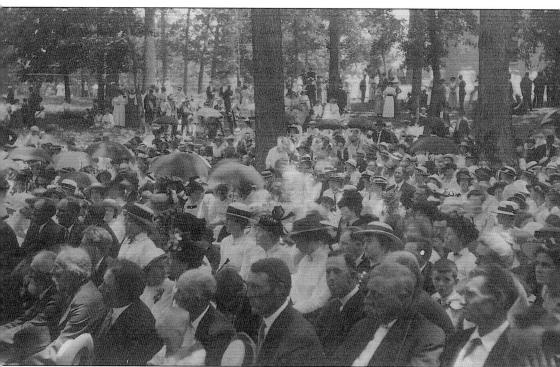

According to Samuel E. Miller, Class of 1935, "Graduations, or commencements as they were called were tremendous occasions. People would come from all over the county in their Model-T Fords and bring their lunches. Picnic blankets were laid down under the oaks in the area by the Science Building. There would be great speakers who would address the graduates and proud citizens in attendance. Sometime in the early afternoon there would be a baseball game that no one would fail to attend. The entire day was filled with all sorts of carnival attractions and games for amusement. It had the air of a county fair." This commencement took place in the open-air stage area behind the Carnegie Library. The stage area was removed in 1936.

The Carnegie Library was built in 1910 and rededicated on October 11, 1991, as the Albert Columbus Tate Library. Tate was valedictorian of the Class of 1894 and taught for many years in western North Carolina.

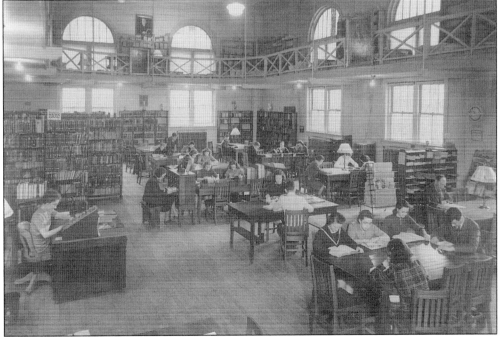

The Carnegie Library originally housed the college gymnasium, and the oval track can be seen here as the second-floor balcony. Basketball was played in this gym; prior to this, all games were played outside.

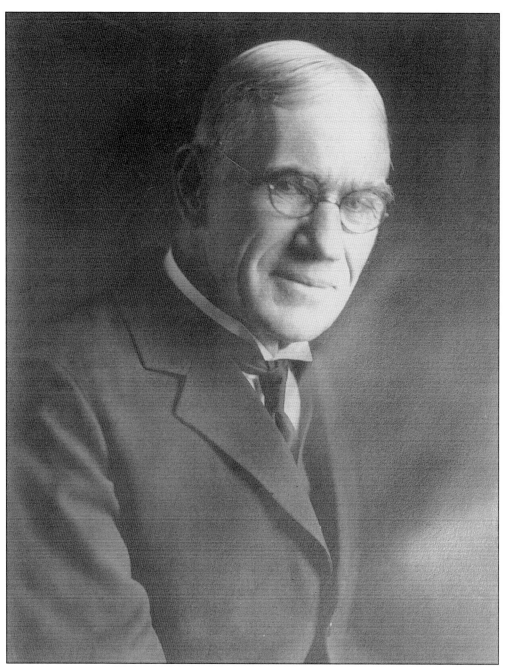

Landon Carter "Daddy" Haynes was a member of the Class of 1877. Following graduation he was appointed professor of Greek and ancient languages; he then changed to mathematics. In 1882, he married Jane Brown, a member of the class of 1880, and the second woman to graduate from the college. Haynes retired as professor emeritus in 1942, after 65 years service to Tusculum College. He held a variety of positions during his time at the college, including interim president in 1907–1908. Haynes died on December 1, 1956, less than three months before his 100th birthday. He is buried in Shiloh Cemetery.

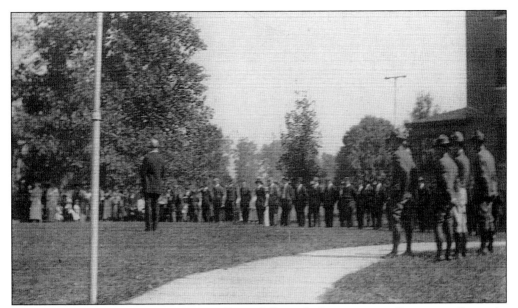

During World War I, Tusculum College followed the pattern of many colleges in forming the Student Army Training Corps, known as the S.A.T.C. Charles Oliver Gray actively sought to have a unit placed at Tusculum, hoping to enlist 100 male students in the program.

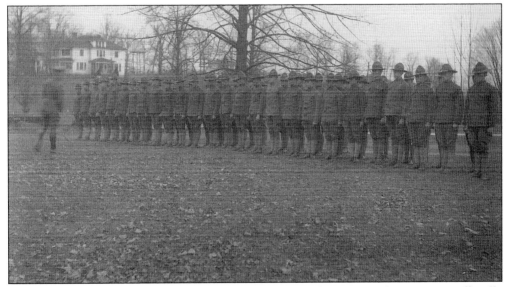

Pictured here is the S.A.T.C. demobilization in December 1918. The unit was officially organized on October 4, 1918, and was short lived due to the end of the war on November 11th. The Tusculum program was not very productive and only served to disrupt the campus. It is believed that the group led to the severe influenza epidemic that swept through campus that fall, suspending classes for two weeks.

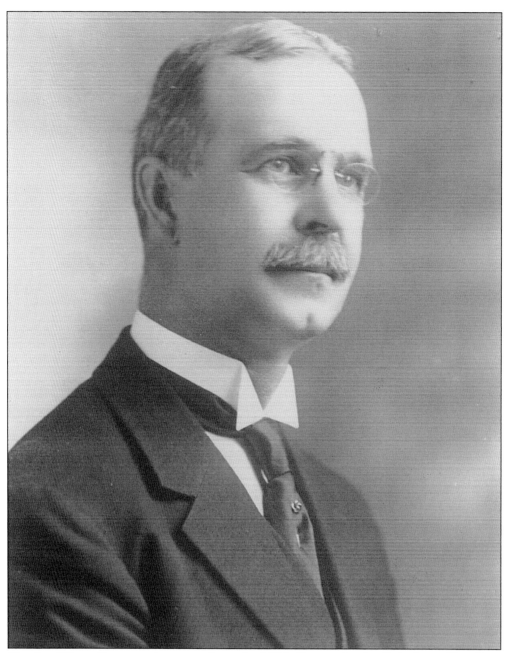

Charles Oliver Gray was born on June 3, 1867. He received a B.A. from Hamilton College in 1890 and graduated from Union Theological Seminary in New York in 1894. He married Florence Irene Rollins in 1893, and in 1903, they moved to North Carolina. Gray spent four years in Marshall before being called to a church in Asheville. In the fall of 1908, he moved to Tennessee to his new post as president of Washington and Tusculum College, where he served until 1931. Only Samuel W. Doak served longer in the presidency. After retiring, Gray continued to work on behalf of the college. He died in 1936 while on a college fund raising trip to Cleveland, Ohio, and is buried in Shiloh Cemetery.

The Science Building was approved for construction on September 13, 1928. Cyrus McCormick II made a final gift to Tusculum of $15,000 to be used to build a science hall. The building was dedicated on June 2, 1930, after a cost of almost $75,000 for the building and equipment. After a major refurbishment, the building was rededicated on April 3, 1989, and named for William L. Tredway of Chester, New Jersey, a member of the class of 1933.

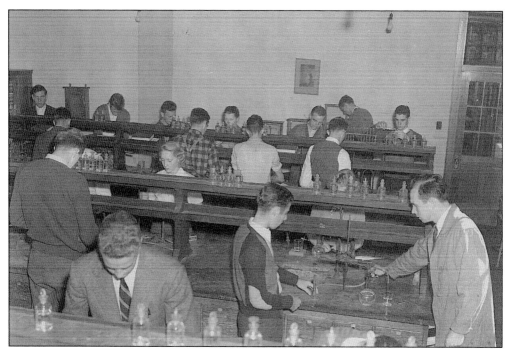

There were two things that made Tusculum different from other schools in its early history. The first was that Tusculum students took one course at a time, a practice that was reintroduced in the 1990s. The second was that there were no graduating classes since students could stand for examination whenever they felt ready. Pictured here is a science class, *c.* 1940.

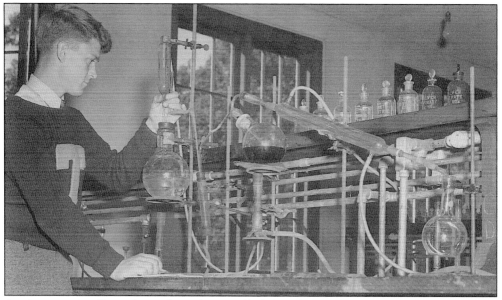

A science major from the early 1940s recalled that they had to catch their own insects for the entomology class. At night the windows were left open and many types of insects were lured to the classroom. The windows were closed and the insects were caught in butterfly nets and then put in cyanide bottles.

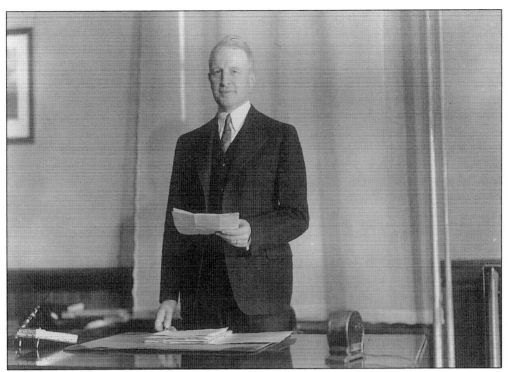

Charles A. Anderson served as president from 1931 to 1942 and was loved by the students and faculty. He deserves more credit than anyone in the development of the college library. During the first five years of Anderson's administration, the library collection grew by almost 30 percent. Surveys of the period show Tusculum spending more per student on the college library than was the national average.

Dr. George K. Davies was inaugurated as Tusculum's president on October 19, 1946. He graduated from Princeton in 1922 and was a 1925 graduate of the McCormick Theological Seminary. He also received a doctor of philosophy degree from the University of Pittsburgh in 1942. Davies served as Tusculum's president from 1946 to 1950.

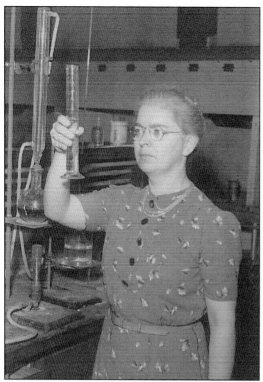

This photograph of Anna Louise Hoffman, professor of chemistry, was taken in 1944. The 1944 *Tusculana* captured the sentiment of students in these grim war years by saying, "Some have been called to fight, and some have been called only to study; some have been asked to sacrifice life, and some have been asked only to sacrifice their selfish interests in self-forgetting effort. With ours, no doubt, the lesser sacrifice, we study to serve, and serve through study - on this the college front."

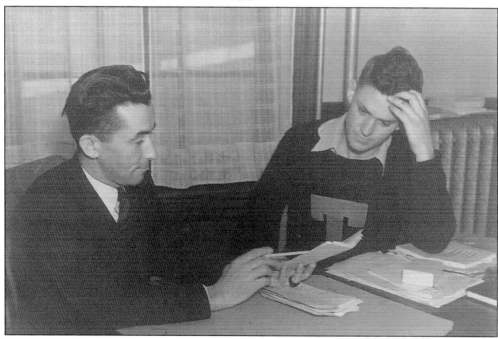

Dr. Cecil M. Shanks, a professor of physics and geology, is pictured with a student. A graduate of Tusculum College, Shanks received his graduate education from the University of Chicago. He became a professor at Tusculum in 1925 and served until his death in 1953. He also served as dean of men.

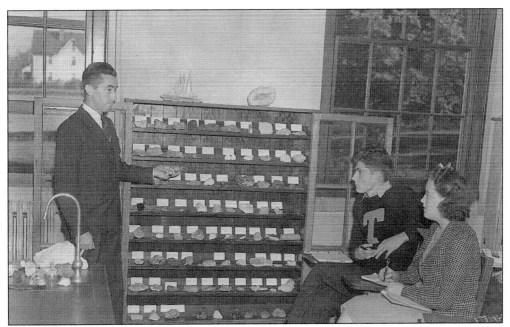

In 1926, Tusculum began a very aggressive recruiting program. President Gray had been concerned over the lack of growth since World War I and saw the need to cast the recruiting net beyond the region. Tusculum began actively recruiting in the Northeast and met with great success.

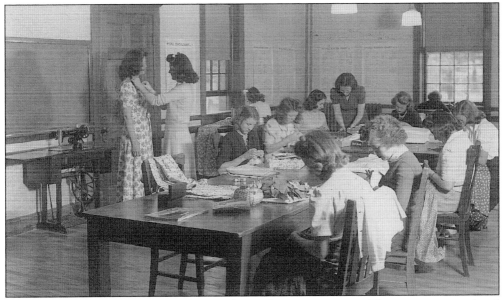

One of the interests of Nettie McCormick was domestic science. The program consisted of three years of instruction in cooking, dietetics, marketing, household economics, drafting, cutting, fitting, sewing, basketry, and embroidery. Pictured here is a sewing class.

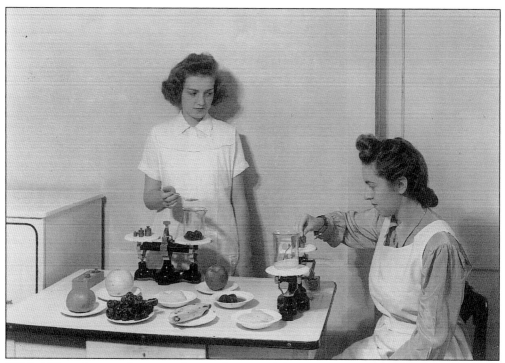

Edith Lillian Stetson became the professor of domestic science in 1908 and served until 1930. She was a graduate of New York State Teacher's College and oversaw many changes in the program during her tenure. Pictured here is the dietary class.

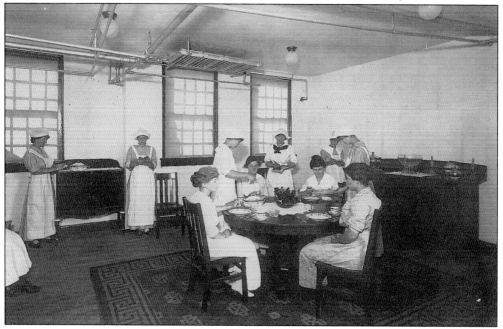

The Home Economics Club offered an opportunity for its members to obtain practical application of their classroom work. Its membership was composed of all female students majoring in home economics. Pictured here is the serving class.

Thomas Samuel Rankin (left) and Landon Carter "Daddy" Haynes are pictured in the 1923 yearbook. Both men served the college with distinction for many years. Thomas Samuel Rankin was born July 15, 1858, north of Greeneville. He attended the preparatory school, went on to receive his degree in 1885, and was then appointed professor of natural science and English literature. He later taught Latin and Greek. He married Mary Coile on her graduation day in 1888. They had seven children, all of whom graduated from Tusculum. Rankin taught Latin and Greek. He suffered his first stroke in 1924 and was in declining health until his death on October 30, 1938. For information on Landon Carter "Daddy" Haynes, see page 44.

Although the United States was not yet involved in World War II, Tusculum was addressing anticipated needs. Tusculum offered a pre-flight training course that was preparing young men to become pilots in the Army Air Corps. In June of 1941, 19 students took courses from a government-employed flight instructor at a landing field in the county. Many of these young men went on to have distinguished military careers.

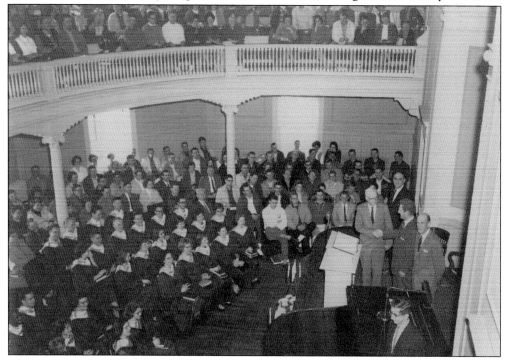

The campus chapel was located in McCormick Hall until the 1960s. When the Annie Hogan Byrd facility was dedicated, the chapel in McCormick was converted into office space. Raymond Rankin, pictured here in the McCormick Hall chapel, served as president from 1951 until 1965. Chapel attendance was required of all students until Douglas Trout's first year as president.

Northern students were attracted to Tusculum because of its low cost in comparison to other schools. Marion C. Edens, pictured here with President Thomas G. Voss, was very successful in recruiting students. He worked at Tusculum as a coach and student recruiter beginning in 1938 before leaving for the Navy during World War II. Upon returning to the States, he went to work in the business world but was called back to Tusculum in April 1953 to lead the student recruiting effort. He left the college in 1972. This photograph was taken in 1975 when Edens was awarded an honorary doctor of humanities degree.

Olivette Suttles, dean of women, is pictured in 1941. She served as dean of women from 1924 to 1942 and, in addition to her administrative duties, was professor of psychology. She was a graduate of Judson College and completed her graduate work at George Peabody. She left Tusculum to take a position with the American Red Cross.

Art Bass, pictured here, was a member of the Class of 1936. In 1924, despite local opposition, the Tusculum Board of Trustees voted to eliminate the academy. Funds were raised locally and the community built Doak High, now known as Chuckey-Doak.

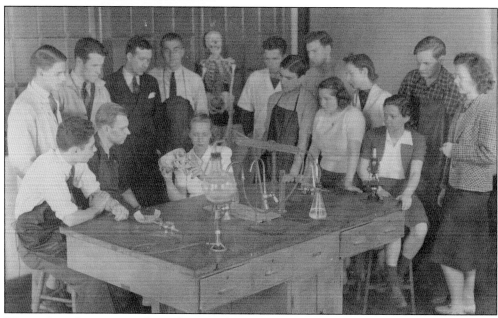

"To make a long story short, let us play a tribute to that part of our faculty, and a part no less significant than any other - those who teach the more unsophisticated class of students. As is the case in everything else, so it is with the college student - he must have a good foundation. To have a good foundation there must be good builders, and we are glad that we can say there are no better builders, and we are glad that we can say there are no better builders than the preparatory faculty of Tusculum." (From the 1921 yearbook, *The Seal*.)

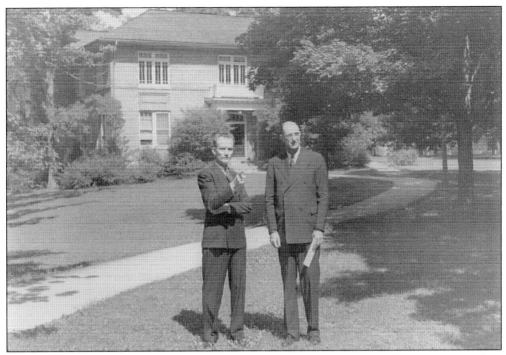

Leslie K. Patton (left), dean of instruction, is pictured with John R. McSween (right), president. McSween became president of Tusculum on October 17, 1942. He came to Tusculum from Presbyterian College where he also served as president. In late December 1944, President McSween was forced to resign due to poor health.

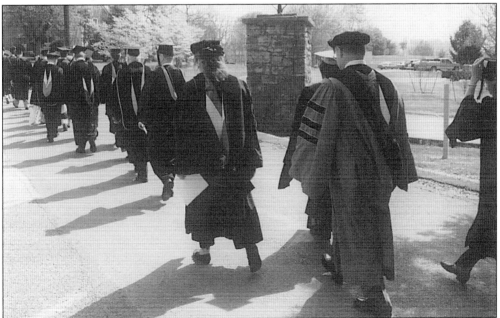

In 1927, Tusculum gained its much-desired accreditation from the Southern Association of Colleges and Schools. President Gray had long desired this recognition and worked tirelessly to meet the requirements.

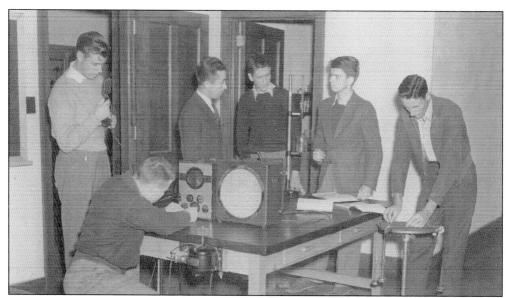

In August 1990, the faculty unanimously approved a major curricular reform and calendar change. The new curriculum placed an emphasis on the civic arts, and the new calendar structured the courses so that students take only one class at a time. This allows students and faculty to engage in learning through practical deliberation. Pictured here is the radio club.

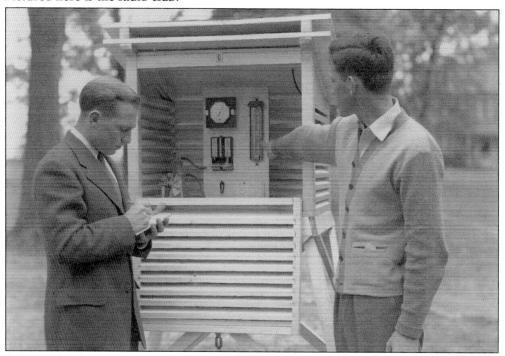

As part of their course work, science students maintained the college's weather station. The radio club was organized in the late 1920s and was made up of students who were taking or had taken college physics. The purpose of the club was to study the fundamental principles of radio.

Pictured here is the cooking class from 1916–1917. Included in domestic science was a course called invalid cookery, which consisted of ten class sessions and was offered to people off campus. It was specially designed for those called upon to cook for the sick. The course covered preparation and cooking of food, diets for common diseases, and discussions on composition, digestibility, and combinations of food.

This presidential reception was held for President Douglas Trout. Pictured from left to right are William B. Boyd, Mrs. Trout, Dr. Trout, Sid Hartle, and Bruce Howell. Trout served as president from 1965 to 1968.

Estel C. Hurley came to Tusculum in 1956 as an instructor. After three years at Tusculum he was named dean of men and, for the rest of his life, was known as Dean Hurley. While at Tusculum he also served as dean of the college, dean of students, dean of admissions and records, and dean of administrative services. He died at his desk in McCormick Hall on January 25, 1993. Numerous students who attended the college during Hurley's tenure attribute their success in college and life to his influence.

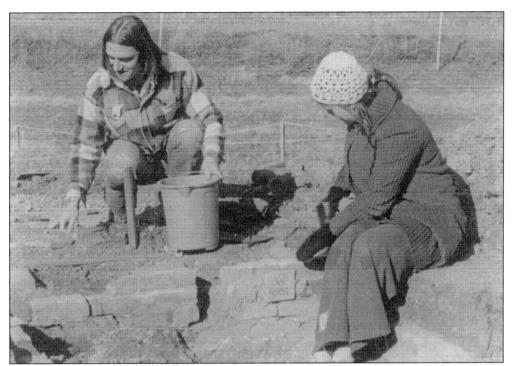

Pictured here is an archaeology course from the 1975–1976 academic year. The science classes have always benefited from the geographic characteristics of the region. This is as true in today's environmental science program as it was in the 1930s when students swam in caves studying fish. In the early years, students used flashlights inside of mason jars to see the fish and other life in the underwater caves.

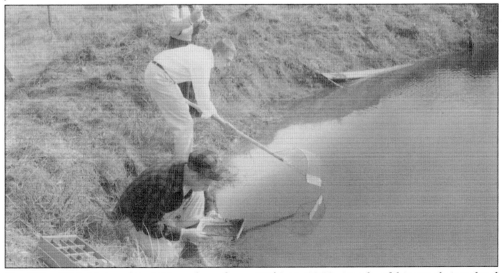

Dr. Mike Wright taught at Tusculum from 1945 to 1950. Much of his work involved aquatic insects, and he did a great deal of research on the lakes and streams in the area. In Frank Creek (College Creek), he discovered four new species of insects. Two of the species were named for Tusculum. They were the Hydroptila tusculum and Isonychia tusculanensis.

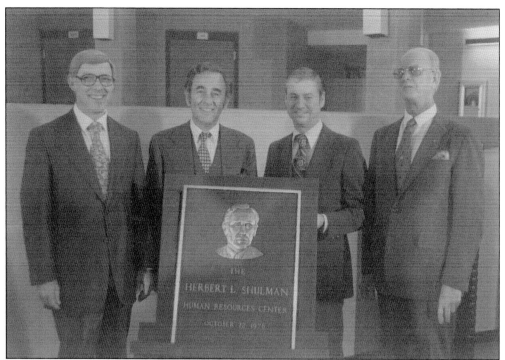

The dedication of the Herbert L. Shulman Human Resources Center took place on October 22, 1976. Pictured are, from left to right, Robert Bailey, Herbert L. Shulman, Thomas Garland, and Jim Armstead. The building was completed in 1971 but was not dedicated until 1976. It was named for Herbert L. Shulman, a prominent Johnson City businessman and former chairman of the board.

The Shulman Center was a "demonstration school" where students at Tusculum gained practical experience working with developmentally challenged people from the Greene Valley Developmental Center. Classes were taught in the outer rooms of the building while they were observed from the center of the building.

President Earl R. Mezoff came to Tusculum in 1978. He previously served as president of Dana College in Nebraska, a post he held for seven years. President Mezoff had a B.A. from Thiel College, a M.A. from Michigan State University, and a Ed.D. from Pennsylvania State University. He served as Tusculum's president until 1988.

Dr. Robert E. Knott served as president from 1989 until 1999. He came to Tusculum from Catawba College in North Carolina. Knott received a bachelor of science degree in mathematics from Wake Forest University, a bachelor of divinity degree from Southeastern Theological Seminary , a master of arts degree in philosophy and religion from Wake Forest University, and a doctor of philosophy degree in higher education from the State University of New York at Buffalo.

President Dolphus Henry assumed the presidency on June 1, 2000. He came to Tusculum from Mercer University in Macon, Georgia, where he served as vice president for enrollment management. He holds a Ph.D. in educational research and evaluation from Virginia Polytechnic Institute and State University.

Charles Oliver Gray Jr., an alumnus and faculty member, wrote the Tusculum College Alma Mater.

Six

STUDENT LIFE

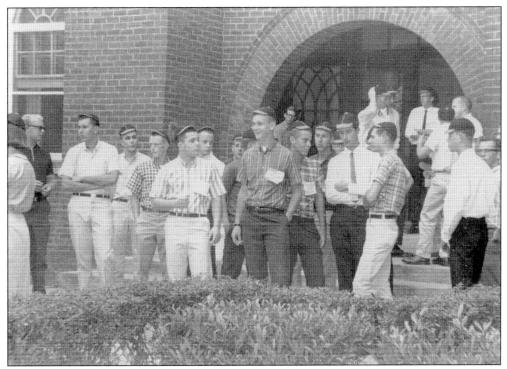

In the early days of the college, punishment was severe for repeated rudeness, gambling, frequenting taverns and distilleries, and for other violations of the moral code.

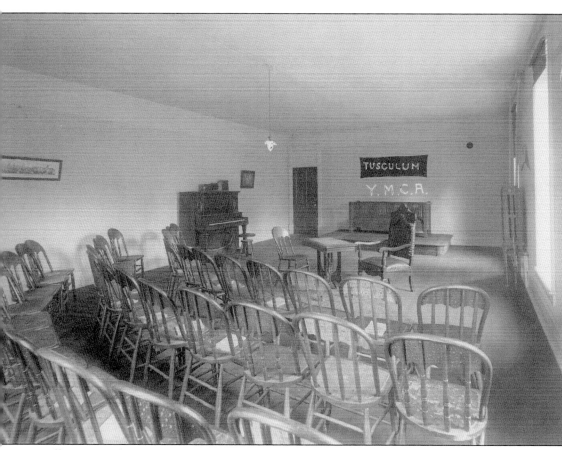

Different student organizations were given rooms in Old College, the library, McCormick Hall, and any other available space on campus. The "Y" welcomed "all men in the institution who desire to realize a full and creative life through a growing knowledge of God and are willing to make a personal program of allegiance and service."

Nurse and instructor of hygiene Martha Witherow is pictured with Tommy Pyle, Class of 1938. Pyle, a native of Kingsport, studied music at Tusculum under Miss Rhea Hunter, instructor of voice. Upon graduation Pyle worked in radio before entering the Peabody Conservatory in Baltimore.

The President's Council was an executive body composed of nine students. They met with the dean of women and dean of men at semi-monthly meetings to act in an advisory capacity. Their function was to exercise control over all student activities and to assume responsibility for student government. Pictured on the far right is Tusculum College president Charles A. Anderson.

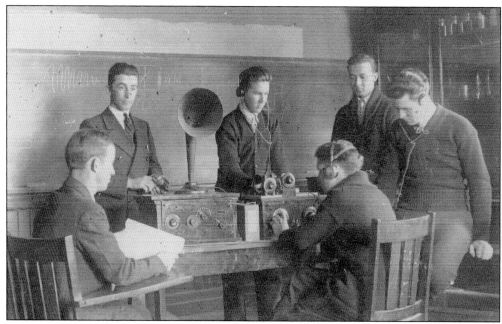

Students registering on January 27, 1947, had the opportunity, for the first time, to register for a course entitled, "Radio Broadcasting and Production Technique." The course carried four hours and involved laboratory work. WGRV in Greeneville donated airtime for students to gain experience in actual radio broadcasting. The course was taught by Catherine Crozier, Class of 1932. Pictured here is the radio club of 1925–1926.

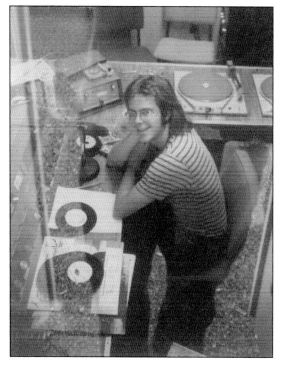

On September 7, 1949, Radio Tusculum (WTCR) sent out its first signal to the campus and community. This photograph was taken in the 1970s.

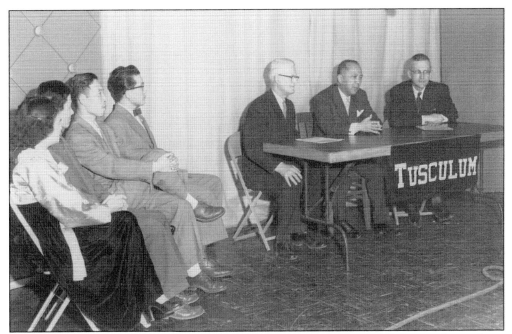

Pictured here are members of the Class of 1955, including, from left to right, Duk Ae Kim (Seoul, Korea), Suh Ho Park (Mapko, Korea), Soung Oak Yang (Seoul, Korea), and Kyong Chol Chou (Pusan, Korea). Pictured at the table are President Raymond Rankin (left) and Dean Edward M. Carter (right). Rankin was very interested in bringing foreign students to campus. In 1952, he approached the Institute of International Education to see if students coming to the United States might attend small colleges.

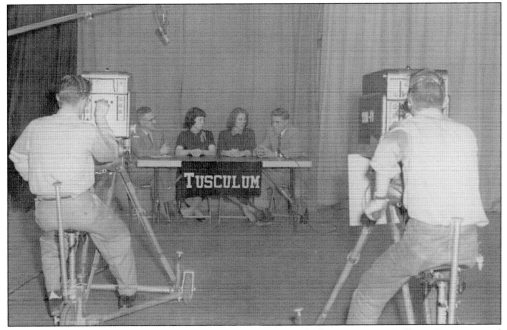

Tusculum produced a weekly television show entitled "Going to College," presented over WJHL in Johnson City. Dean Edward M. Carter produced the program.

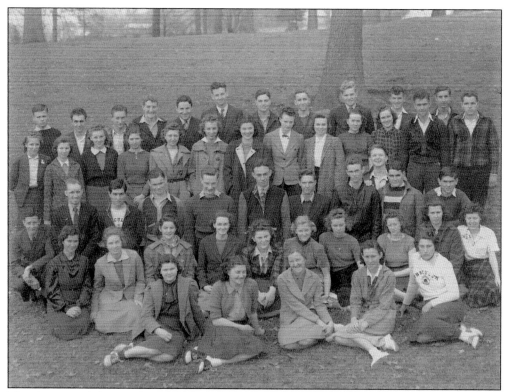

The Outing Club was founded in 1931 by Herrick Brown, Class of 1935. It was the first Southern member of the Intercollegiate Outing Club Association, joining in 1933. Membership was limited to 50 students, equally divided between boys and girls. Members were elected based on their interest and experience in the outdoors.

In the fall of 1907, the entire student body went to the Smoky Mountains for an outing. This was the first official Mountain Day, a tradition that continued into the 1970s.

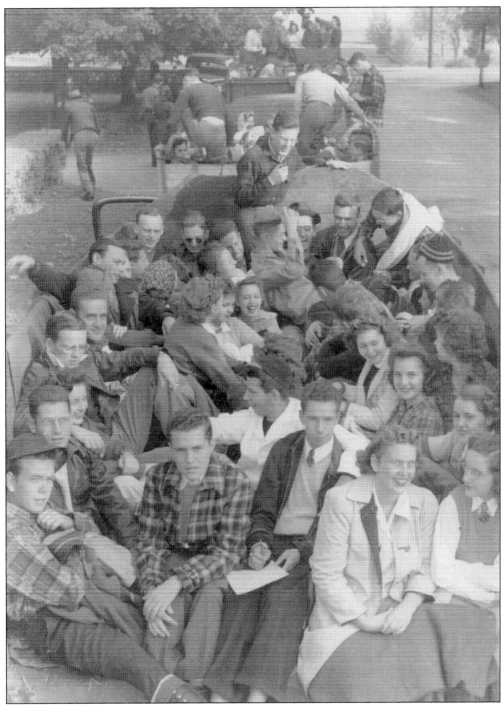

This is another view of Mountain Day. Literary societies were very popular on campus, especially in the 19th century. There were three literary societies on campus (two for men and the other for women). The men's societies were the Philomathean (organized in 1839) and the Philologian (organized in 1948). The women's organization, Clionian, was organized in 1882. Each group met weekly in rooms furnished for their use.

Tusculum was able to attract students through the Depression by minimizing financial obligations. Students were able to work to offset tuition, and some students were sent to Tusculum with assistance from their churches. One student told about receiving a calf from his father at the beginning of each year. He would sell the calf and thus have money to use throughout the year.

One of the outdoor clubs at Tusculum was the Floyd Collins Club. The group was named for a man who lost his life in a sand cave in Kentucky, and the club was formed so that male students could make expeditions and have experiences in cave exploration. The outing pictured here took place at Greystone.

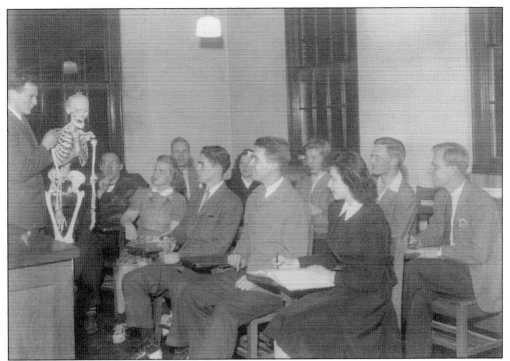

The Archiatrus Society is pictured in 1941. This pre-med club was formed in 1929 by Mary Campbell (Class of 1930) and a group of students with medical and pre-nursing interests. The name "Archiatrus Society" was adopted in 1940, and club membership was open to sophomores, juniors, and seniors who were science majors.

The staff of the *Pioneer* is pictured in 1944. The *Pioneer*, established in 1938, was the Tusculum student newspaper.

Paul and Peder Larsen were members of the "Skinny Club," a World War II–era group of about 15 Tusculum men who needed to gain weight to meet the minimum wartime standards. After receiving physical examinations, these young men returned to campus with the news that they had to put on weight to qualify for military service. They met with the dietitian, who put them on a diet of milkshakes, steaks, bananas, and peanut butter and jelly. They ate several times throughout the day, and on the day they were to report for active duty and another crucial weigh-in, they ate several bananas and drank lots of water. Happily, they came in just over the minimum weight.

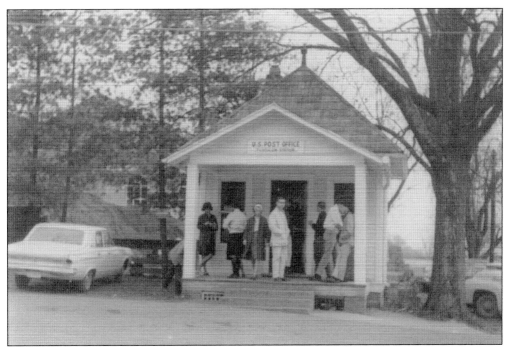

Prior to World War II, the post office was moved from just below Dobson's Store to the back of Morgan Hall. It was moved again in December 1965 to the west side of Shiloh Road near Haynes Hall. This picture of the campus post office was taken in December 1965.

The Polity Club was composed of students majoring in social sciences who were interested in current events and issues of international significance. There was also a Creative Writing Club, composed of students interested in finding a helpful and sympathetic audience for their literary efforts.

The Federal Works Administration certified Tusculum as eligible for much-needed floor space. Several buildings were given to the college, and this one was used as the student union building. It was called the "SUB" by students. The construction of a new student center took place during the academic year 1969–1970. The new building was formally dedicated on February 12, 1977, to the memory of Robert Jennings Simerly and his mother, Mary Benton Mitchell Simerly. Named the Simerly Union Building, it was incorporated in the Scott M. Niswonger Commons, which was officially dedicated in October 1999.

Dobson's Store served Tusculum College students starting in 1892. For a period, Pop's was located next to Dobson's Store. Both of these establishments served the student's need for ice cream, cokes, and other sundries.

Pictured here is Harold Dobson, one of the many generations to run the family store.

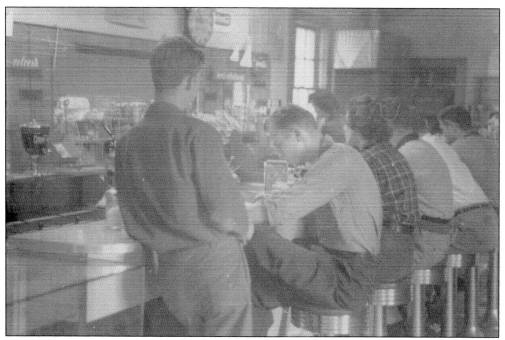

The SUB was opened following spring break of 1948. The building, as well as a building for the business office, came from Camp Forest in Tullahoma, Tennessee. They were dismantled, transported to campus, and rebuilt at a cost of $19,892.94, which was paid by the Federal Works Agency.

With the arrival of the new building, Tusculum was required to pay for the foundation and site preparation, hardwood flooring and paneling, decorations, light fixtures, and "approximately $8,000 worth of the latest and most modern equipment available."

The May 18, 1948, the *Pioneer* stated, "The Student Center offers much more to the students of Tusculum than merely a place for chatting over a coke. Already it has served as a site for college receptions, sings, and other informal gatherings. Many students have found it advantageous to supplement their incomes by working behind the counter. Mrs. Ramsey has added a charm and graciousness that few college students may find in campus centers at other colleges."

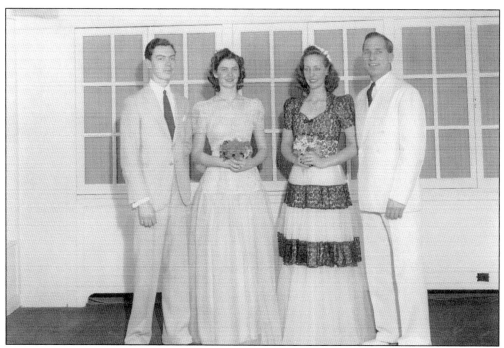

The May Court is pictured in 1941. From left to right are Thomas Pyle, King's Attendant; Virginia Hubbs, Maid of Honor; Virginia Martin, May Queen; and Edward Heinz, May King. The May Court was named to reign at the annual May Day celebration.

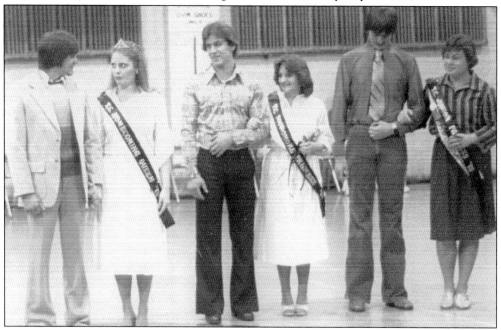

During the 1978–1979 school year, Homecoming was re-introduced to Tusculum College and revolved around basketball. Pictured is the Homecoming Court for that year. The king was Marvin Leach, and the queen was LaWahna Teasley, pictured here second from left with her escort Steve Layendecker.

Dances were one of the most popular events on campus, before and especially after World War II. The T-Club, the dormitories, and other organizations held these events. The most popular was the "Gum Shoe Hop."

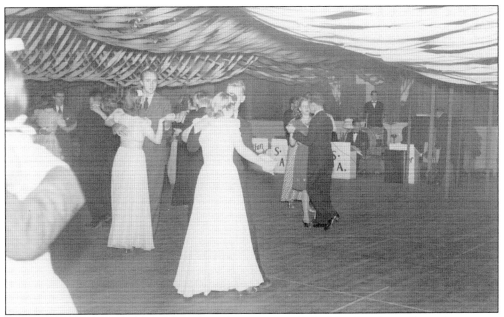

In the early years of the 20th century, dancing was forbidden by the college. It was not necessarily due to the opposition of the administration, but was opposed by college donors and patrons. Pictured here is a dance in 1942.

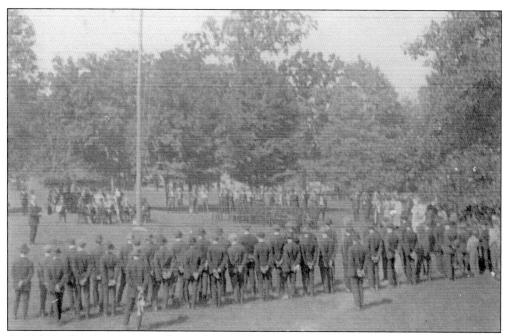

In 1921, a flag base and staff was designed by Richard Beeson and was dedicated that same year to those who had made the supreme sacrifice. Around the base were the names of the five Tusculum students killed in World War I. They were Pvt. Oscar B. Harrison, Sgt. Charles D. Johnston Jr., Pvt. Paul Masters, Lt. Robert E. Mitchell, and Pvt. Royal J. Stokely Jr. Five trees were also planted in their memory in front of the library.

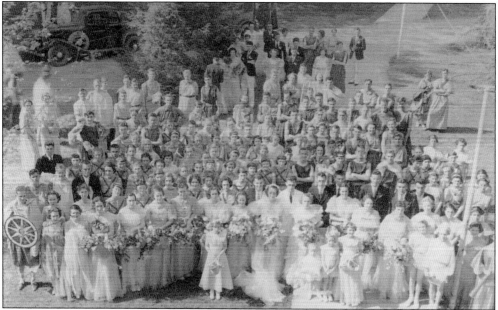

May Day was an annual tradition at Tusculum and was celebrated the first Saturday of May. It was a full day of events with the president crowning the May Queen, and the Glee Club presenting an operetta for the queen, her court, faculty, students, and guests. This photo was taken c. 1935.

The Polity Club, an affiliate member of the International Relations Clubs, was a discussion group formed to stimulate interest in current, domestic, and foreign events.

More than one freshman arriving from the Northeastern United States thought he or she would develop a little bit of a Southern accent. They were surprised to arrive on campus and discover that nearly half of the students also came from the Northeast.

In the 1935–1936 student handbook, rules listed included the issues of smoking, drinking, and marriage. Men were allowed to smoke in the dormitories but women were forbidden to smoke on campus. Drinking alcoholic beverages was strictly forbidden. Students who married during the school year were expected to withdraw from college immediately. This photograph was taken in the 1960s, looking out of the front door of the library.

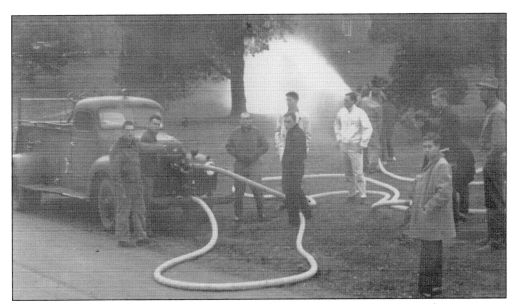

This Tusculum volunteer fire department photograph was taken in 1967. For many years, Tusculum students served in this capacity. Many also volunteered to help the U.S. Forest Service contain forest fires.

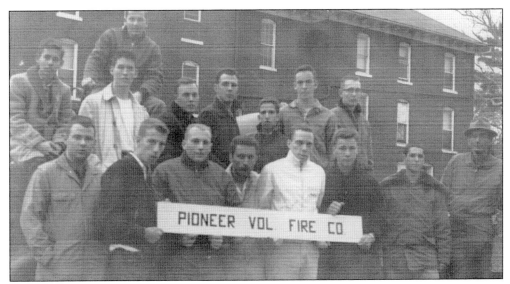

Students served for many years on the Tusculum Volunteer Fire Company. The college had a fire truck and students served as fire marshals.

Tusculum officials attempted to eliminate the hazing of freshmen students. When they realized that this was impossible, they attempted to regulate it by limiting it to one week, called "hell week." This photograph was taken in the 1970s.

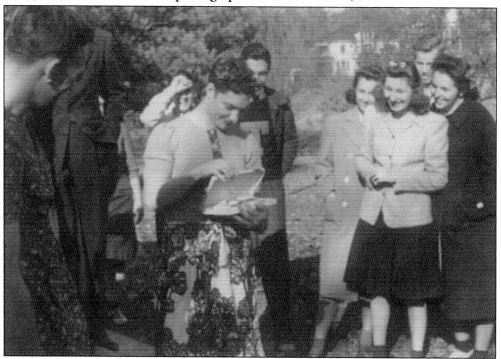

During "hell week," freshmen were subjected to the whims and fancies of upperclassmen. They dressed in strange attire and performed unusual stunts. It was difficult for the administration to remove hazing because the sophomores wanted revenge for the way they were treated when they were freshmen.

In addition to the hazing of freshmen, several clubs and student organizations required their new members to go through some type of initiation. New faculty members joining these campus organizations were required to go through the same initiation as the new students.

Any failures of the freshmen to perform their duties resulted in a "rat court." The most common penalty handed out by the court was paddling. There was an unwritten rule that only male students were paddled.

Students sometimes dressed in togas. These men pose in the area between Rankin, Craig, McCormick, and Haynes Halls, *c*. 1970s.

This student demonstrates his political affiliation. The sign reads, "I voted for Roosevelt."

During World War II, the few students who had cars did not use them. Gas rationing created problems for the students and the administration decided to allow female students to hitchhike to Greeneville during daylight hours.

Tusculum students were not immune to the crazes that occurred on campuses around the country. One of these crazes was cramming as many students as possible into a car.

Tusculum students thoroughly enjoyed all of the school's special events. Pictured here is the Pioneer Days celebration in 1931.

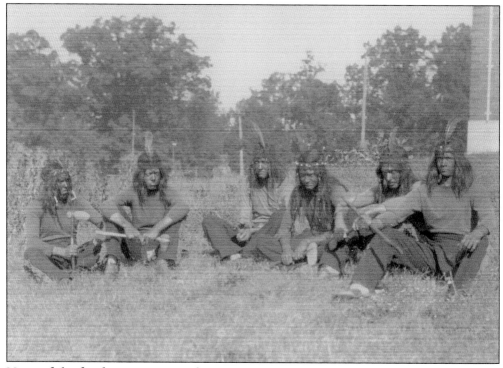

Many of the fondest memories of time on campus revolve around annual events and social activities. This photograph was taken in the 1930s.

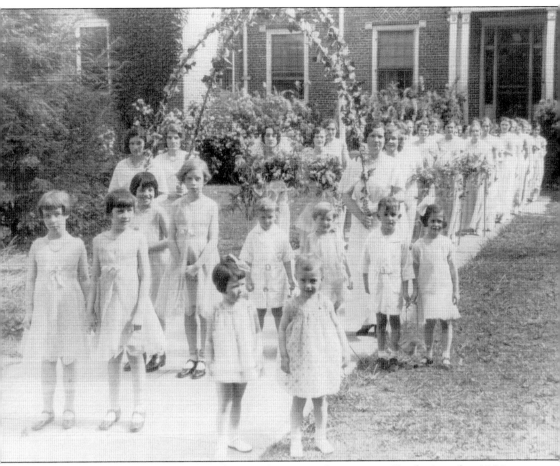

The May Day event was popular during the 1920s but especially during the 1930s. Students prepared a traditional May Pole. The May Day celebration on campus was discontinued when the United States entered World War II. This photograph was taken in 1931.

Dormitories and student organizations periodically held dances and parties. This picture was taken at the 1924 spring party at Haynes Hall.

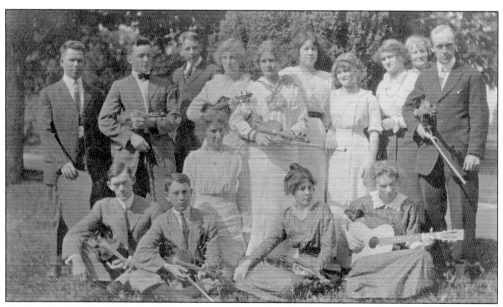

During the first half of the 20th century, Tusculum had a very respected music program. This is the Tusculum orchestra for the school year 1913–1914.

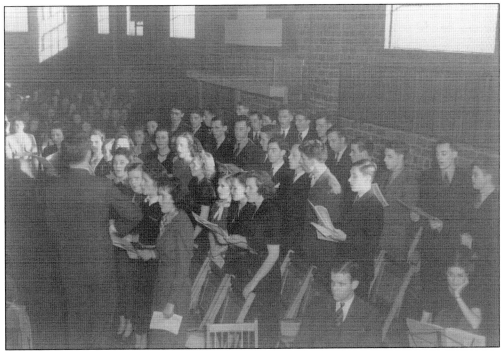

Tusculum had two glee clubs, one for women and one for men. Each had a maximum membership of 25, and students were required to audition for the group.

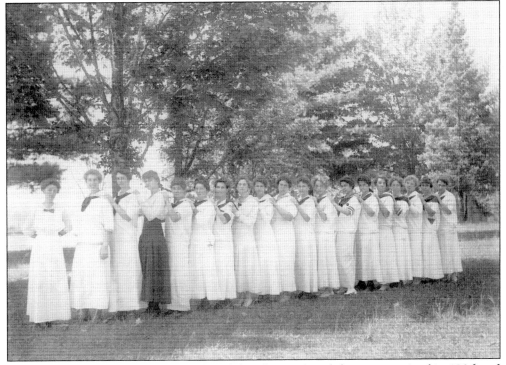

Mrs. McAmis is pictured with her glee club. A boys' glee club was organized in 1906 and a girls' club in 1907.

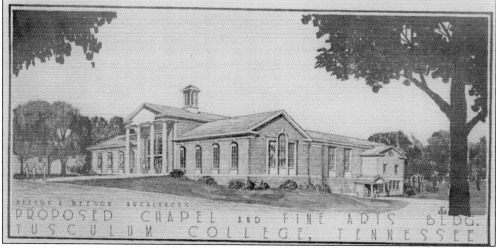

CHAPEL-FINE ARTS BUILDING UNDER CONSTRUCTION

PROPOSED CHAPEL AND FINE ARTS BLDG.
TUSCULUM COLLEGE, TENNESSEE

Pictured here is a rendering of the Annie Hogan Byrd Fine Arts–Chapel, dedicated September 15, 1965. It was named for the wife of Thomas H. Byrd, a longtime trustee and major donor to the project.

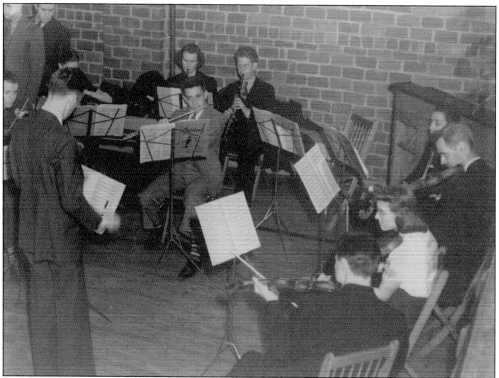

The Tusculum College Orchestra gave concerts throughout the year on campus and in the community. It would accompany the Glee Club in some of their performances and also performed for the May Day pageants. In this picture the orchestra is being directed by Virgil Self.

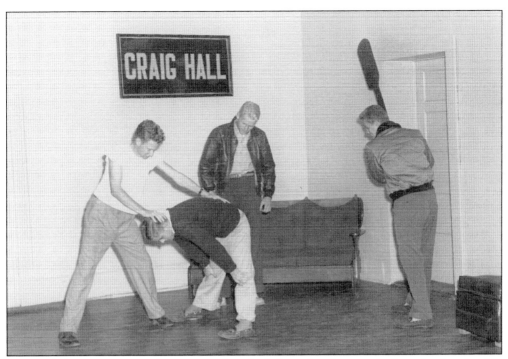

Some of the most severe hazing was handed down by the men's dormitories. In this photograph, students of Craig Hall paddle one of their "rats."

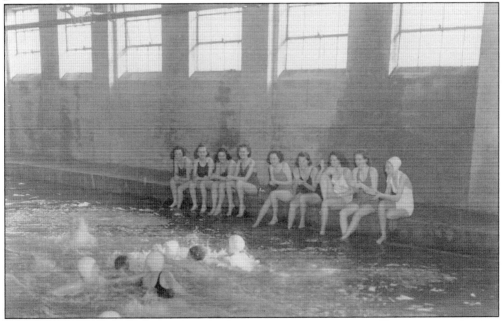

For many years Tusculum College had a swimming team, as well as an organization known as the Swimming Association. The Swimming Association was composed of members of the swimming team who had earned a letter in swimming. The purpose of the organization was to develop a spirit of fellowship and good sportsmanship in the field of aquatics.

It was required until the second half of the 20th century that all women must be in their dormitories ten minutes after the close of a social function. Male students were also told that courtesy demanded that they bring their dates to the dormitory door and leave immediately.

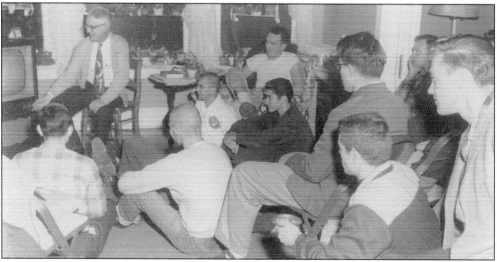

Several times during President Rankin's administration tensions flared between he and the students. Mrs. Rankin actively tried to cool tempers by inviting students into the President's House for after-date parties and other social events. Pictured here are students watching television with President Rankin.

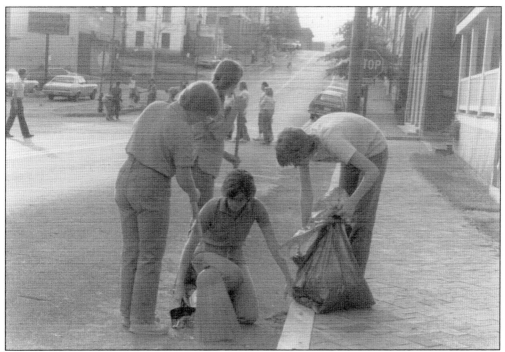

In January 1913, the trustees voted to have a day in February in honor of Nettie McCormick. The day was full of events and social activities for the students. This tradition continues today but is now a day of community service for the campus. Students, staff, and faculty go into the community to clean, repair, and complete chosen projects. Here, 1982 freshmen are initiated by cleaning Depot Street in Greeneville.

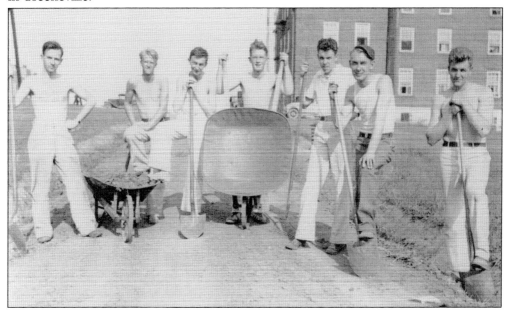

The students pictured here are working on a campus road that passes between Craig and Rankin Halls.

97

The senior lantern ceremony is held at the end of each school year and symbolizes the passing of the torch from the graduating seniors to the upcoming seniors. This event was created by Robert C. "Bobby" Soule and William Hunter, both members of the Class of 1938.

Seven

CAMPUS LIVING

For many years campus life was dictated by the McCormick Hall bell. In the 1935–1936 student handbook, the schedule is as follows: rising call 6:40; breakfast bells 7:05-7:10; first class bells 7:40-7:45; chapel bells 9:40-9:45; third class bells 10:10-10:15; lunch bells 12:20-12:25; first afternoon class bells 1:10-1:15; dinner bells 6:00-6:05; social bells 6:40-6:45; and taps 10:00.

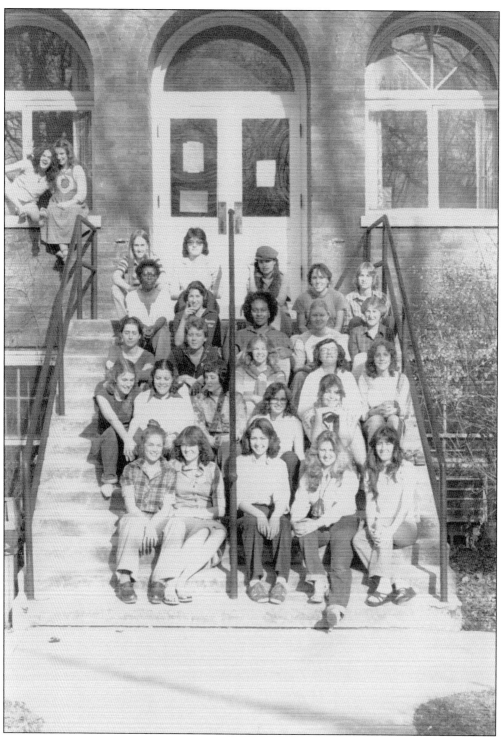

Pictured here are the women of Virginia Hall, 1978–1979. Today Virginia Hall houses administrative offices. Virginia was considered the first modern building on campus; it contained the first flush toilet in the area.

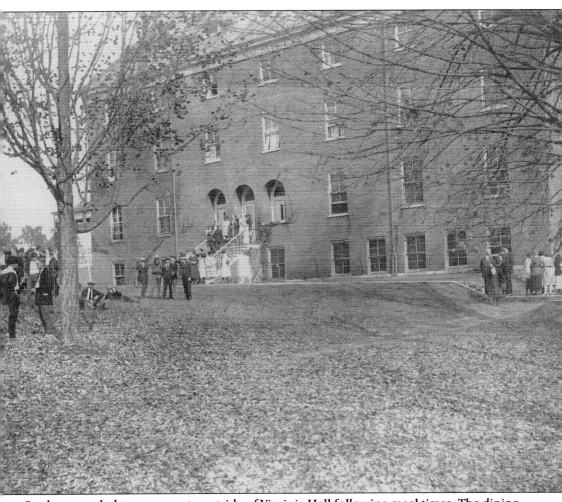

Students tended to congregate outside of Virginia Hall following meal times. The dining hall was in the basement of Virginia for many years. When it was first built, it was called Virginia McCormick Hall.

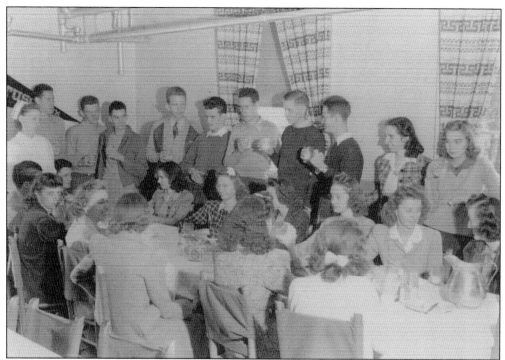

One of the things that appealed to Nettie McCormick was that Tusculum students were frugal and that they grew their own food and prepared their own meals. This practice did not last. However, a male student from the early 1940s recalls hunting for rabbits in the fields between campus and the mountains and taking them to the cooks in the dining hall.

Students were allowed to have guests for meals in the dining halls but were required to make arrangements in advance. Students were expected to be in attendance for all meals.

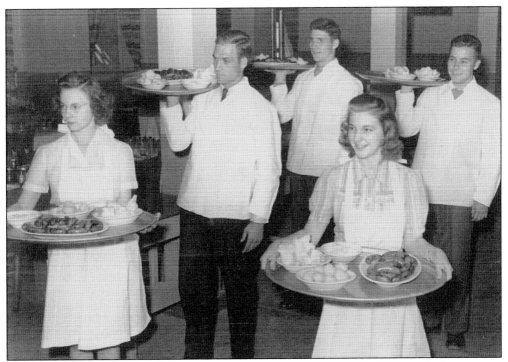

Many students worked as servers in the dining hall throughout the school's history.

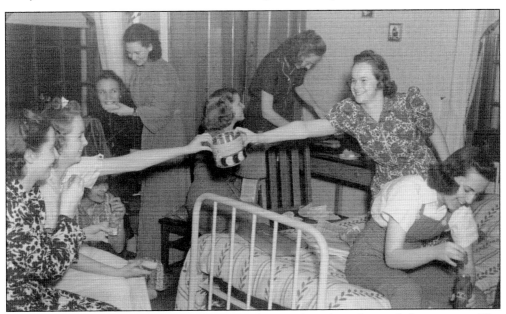

As recalled by a member of the Class of 1945, Pearl Harbor changed the campus. The student remembered the day that Pearl Harbor was attacked: "That night around eleven you could hear singing from the men's dormitories. They came across campus singing and had a panty raid in the women's dormitories. The men took their trophies and ran them up the flag pole." To the best of her recollection no one was disciplined for the raid. Seen here is a typical women's dorm room scene.

According to the 1951–1952 student handbook, "Women had to be in their dorms at 10:00 PM Sunday through Friday nights, 11:00 PM on Saturday nights and the night before a holiday, midnight on the night of formal dance for girls who went to the dance, 11:00 for the wallflowers."

The *Tusculana* staff of 1941 are seen working in dormitory.

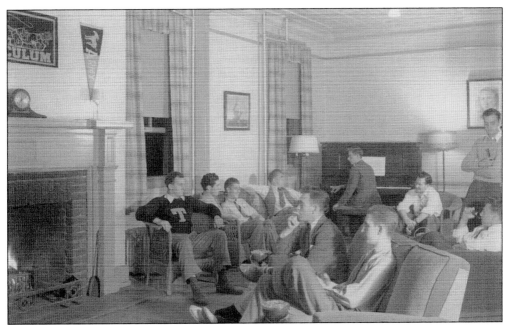

The men of Craig and the men of Rankin had an ongoing rivalry similar to that of fraternities. In 1944, due to a shortage of men on campus, the college was forced to combine and unite the men formerly living in Rankin Hall with those living in Craig. When football was suspended during World War II, spirited games were played between the men of Rankin and Craig.

Rivalries were common between the men of the different dormitories. Pictured here are the "Men of Craig." During World War II, Craig Hall remained a men's dorm but Rankin Hall was taken over by the women.

Morgan Hall was reopened to men on March 7, 1946, as the need for space for the returning men grew. Their McCormick Day project was to completely overhaul the building. Pictured here are the "Men of Morgan."

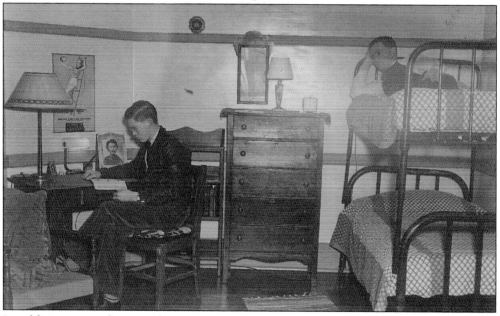

In addition to students in dormitories, shown here, there were many day students in the life of the college. These students lived in the local community and did not reside on campus. They are considered an active part of the campus and have always been recognized as such.

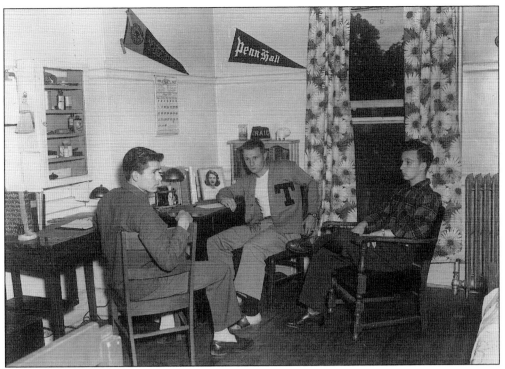

These students are pictured in Craig Hall, probably during the 1950s.

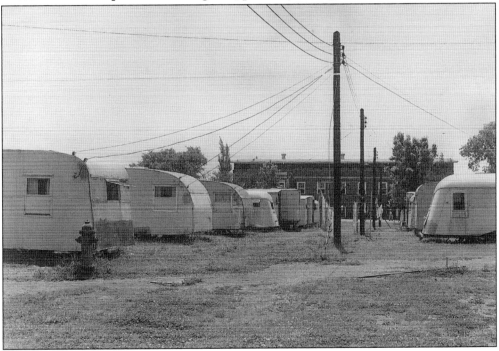

"The Trailer Colony" was occupied following World War II by married students and their families. The trailers were in the area bounded by Rankin, Craig, McCormick, and Haynes Halls. The complex consisted of 14 trailers, which were all removed by 1952.

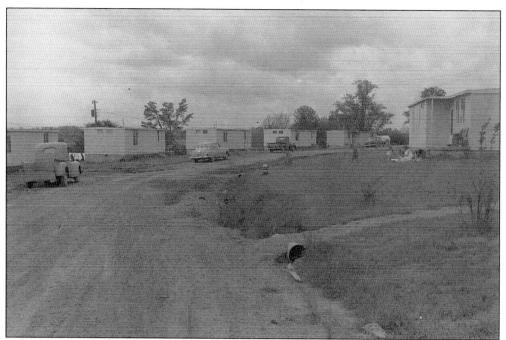

"The Trailer Colony" was also referred to as "Trailer City" or "Trailer Village." Tusculum benefited from the G.I. Bill, and in the fall of 1946, 416 students enrolled. This was the highest number in school history. There were 221 freshmen, and of these, 163 were men and 112 of those were veterans.

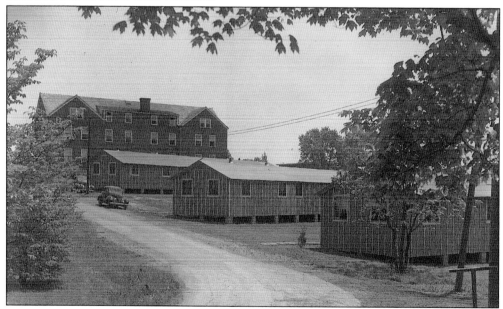

Tusculum College received barracks buildings from the Federal Works Administration in 1947. On January 25, 1947, three of these were put to use as dormitories for 16 male students each. The buildings were called Balch Dormitory, Doak Dormitory, and Coile Dormitory. There was also one apartment dorm with three apartments for married students. It was called Moore Apartments.

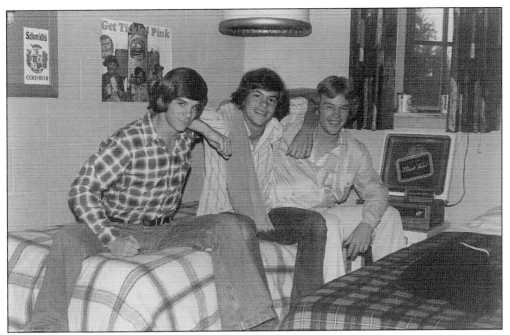

This dormitory scene appeared in the 1975–1976 school year.

Katherine Hall was dedicated on October 18, 1962. The dorm, named for President Rankin's wife Katherine, housed 96 women.

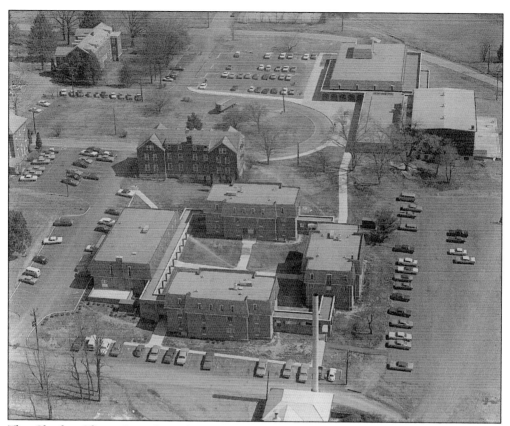

The Charles Oliver Gray Complex, seen in this aerial view, was opened in the fall of 1969. The complex was designed as four buildings around a grass commons. Among other things this complex today houses classrooms, faculty offices, and student housing. The complex is referred to as "COG."

Eight

ATHLETICS

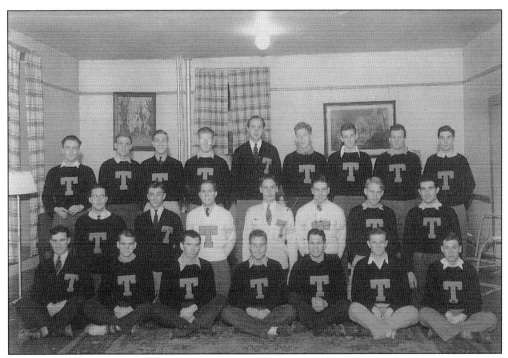

The goal of the "T" Club was to promote good sportsmanship and a keen interest in athletics. Membership was open to those who lettered one year in one of the major sports or three years in the minor sports. Members went through "hell week" before initiation, which included such harmless pranks as a chicken census in Greene County and carrying an egg for three days. This photo is from the late 1930s or early 1940s.

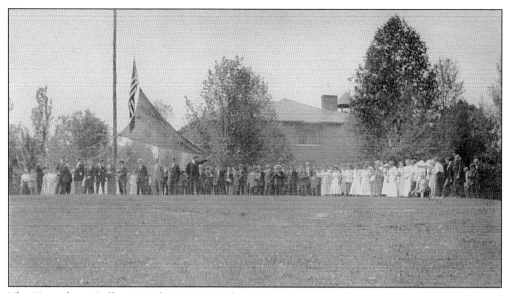

The Tusculum College track team won the 1913 Bristol Track Meet championship. They were extremely proud of this major accomplishment, and the entire campus turned out to see the championship banner run up the flagpole.

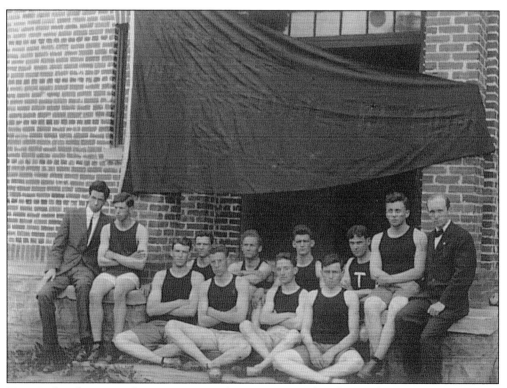

Here is the championship winning track team pictured in front of Rankin Hall.

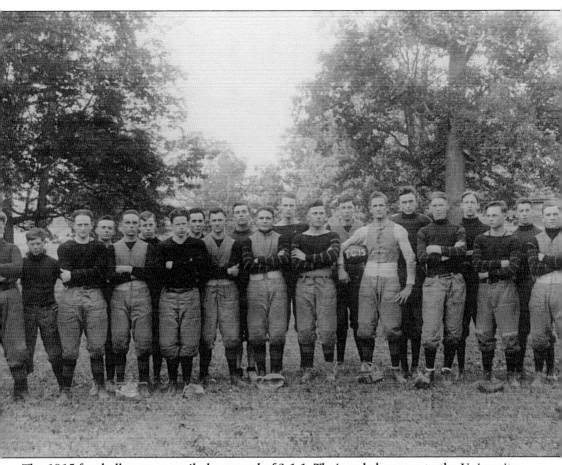

The 1915 football team compiled a record of 3-1-1. Their only loss was to the University of Tennessee and the tie was with Maryville College. This team defeated Carson-Newman 23-0. In 1919, Tusculum defeated Carson-Newman 103-0.

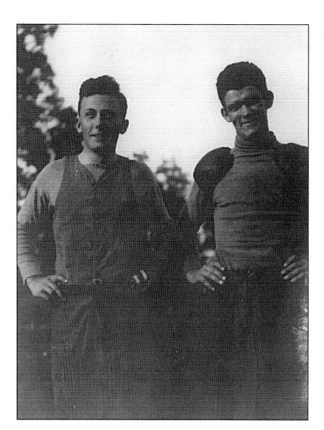

Sam Doak, left, and Fred Clemons, right, are pictured in 1908 or 1909.

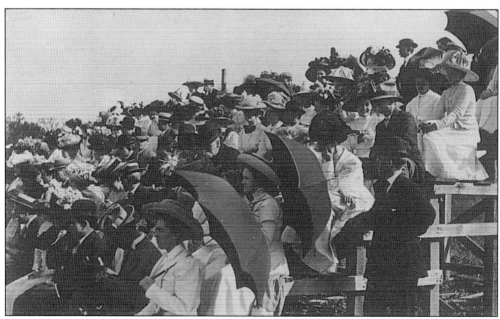

Baseball and football games were always social events in the first half of the 20th century. This picture was taken at a commencement day baseball game, *c.* 1910.

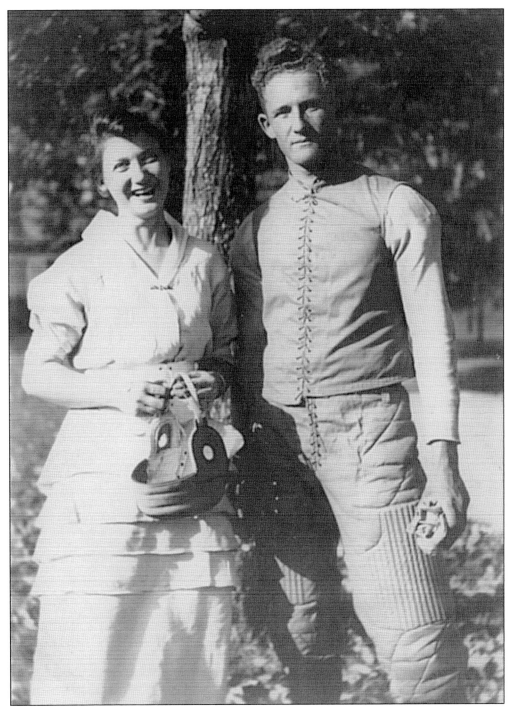

This member of the 1914 football team was part of the team that defeated Carson-Newman and Knoxville High School. They lost to Maryville College, and the results of their game against King College is unknown. Football began at Tusculum as an informal sport in the late 19th century. The first recorded game was in 1902 against Washington College, and Greeneville and Tusculum College lost 18-0.

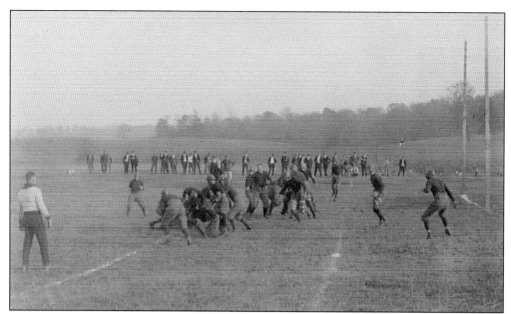

The "T" Club, an organization of student athletes, recognized the need for a football seating area for spectators and took on a project in 1941 to construct concrete bleachers. They raised money through a variety of means and members of the club provided the labor. The project was started in 1941 with the hope that future clubs would continue the project.

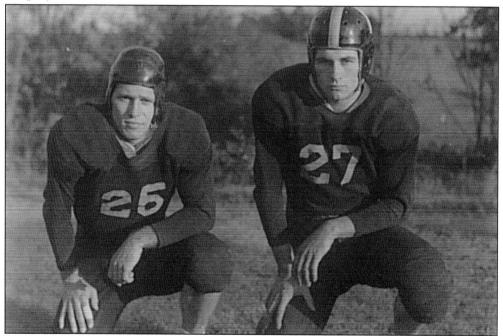

Co-captains of the 1940 football team were Ed Heinz (Class of 1942), left, and Ted Marshall (Class of 1943), right. The 1940 team compiled a record of 1-7. Their only win came against Brevard Junior College. Football was suspended at Tusculum during World War II.

116

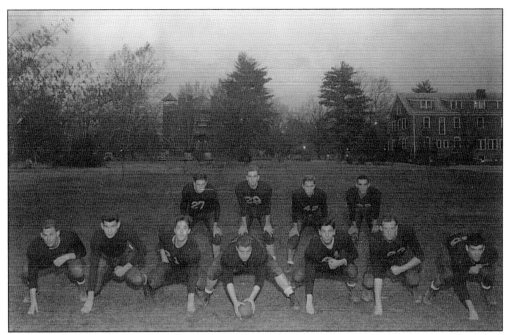

Football was suspended during World War II due to a lack of men on campus.

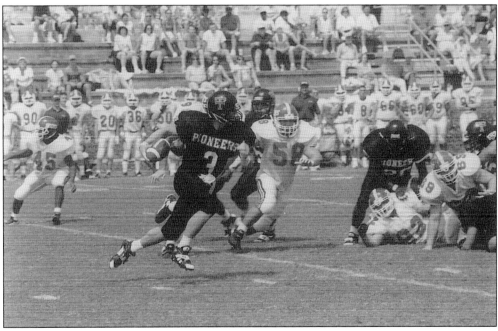

The football program was officially abolished following the 1950 season. The college had suspended several seasons before this, but the program ceased in 1950. In 1991, football was re-introduced at Tusculum with that year's team compiling a 0-10 record. Tusculum played Clinch Valley College in its first game of 1991. Pictured here is Andy Smith in the September 5, 1998 game against Maryville College.

Tusculum College did not have a marching band but several students took it upon themselves to improvise.

Charles Oliver Gray was very strict on athletes; he felt that they deserved no favors. He was opposed to what he thought other schools did with their athletic programs and what he thought was an unnecessary emphasis on athletics and their commercialization.

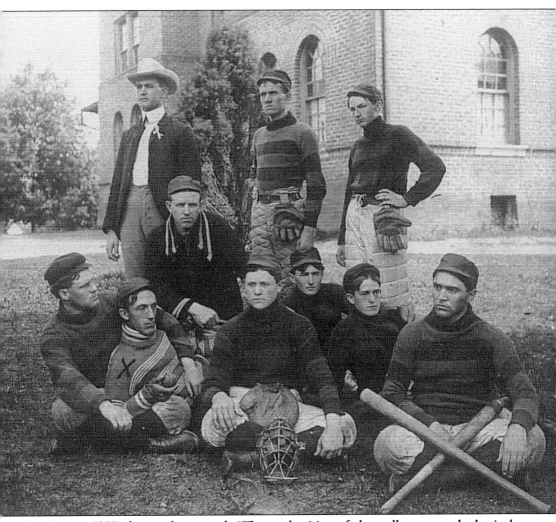

Starting in 1907 the catalog stated, "The authorities of the college regard physical training, during the formative period of student life, as a matter of great importance. To this end, therefore, every legitimate aid is given the students tending to encourage athletic sports."

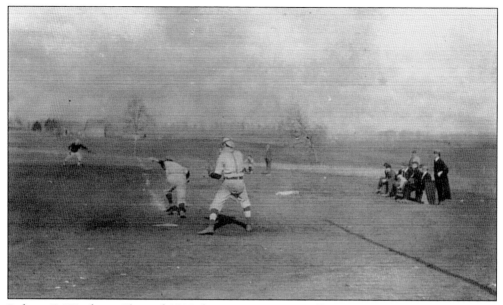

Robert C. Wardrep, Class of 1918, bats against King College in a 1914 game.

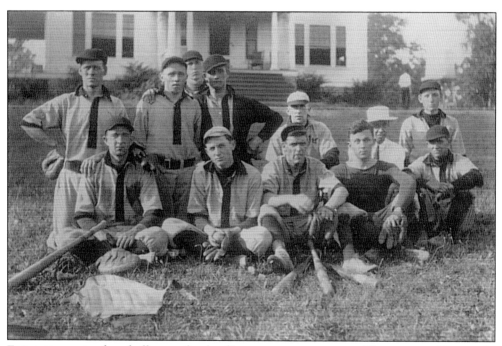

For many years baseball was the leading sport on campus. There were 63 people competing for positions on the 1908 team.

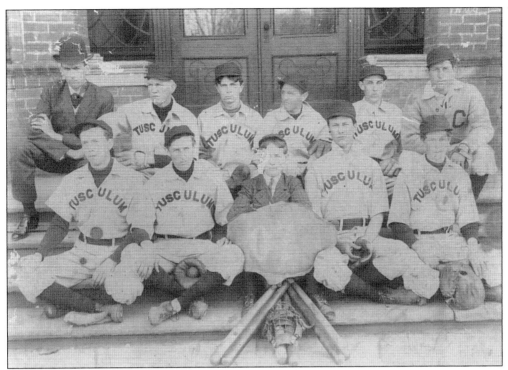

Several students who attended Tusculum earned income by playing minor league baseball in Johnson City.

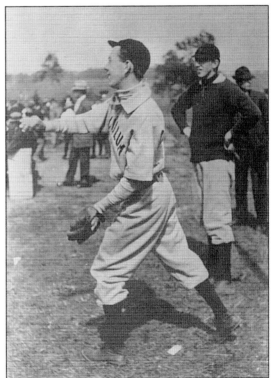

Unfortunately, complete records of the baseball team do not exist. The teams had long seasons during which they played other colleges, high schools, traveling minor league teams, and any other team that came through East Tennessee.

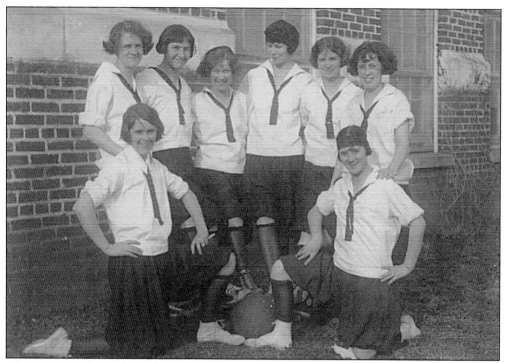

The women's basketball team of 1924–1925 is pictured here. Women's basketball was discontinued in 1930 and returned to Tusculum in 1979.

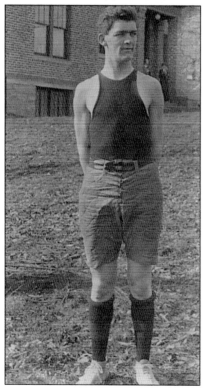

Fred Clemons is pictured here on February 28, 1912. This Elizabethton native was active and successful in several Tusculum sports.

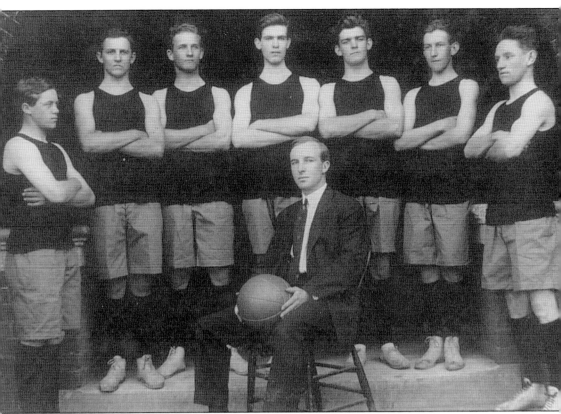

In 1917, in front of a frenzied crowd, the Tusculum basketball team defeated the University of Tennessee, 18-17. The game was played in the gymnasium part of the Carnegie Library.

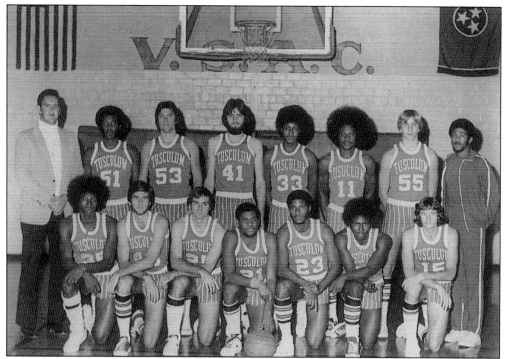

Men's basketball has been at Tusculum since the early 20th century. This is one of the few sports that has been played uninterrupted at the college. Pictured here is the team of 1976–1977.

The Pioneer Gym was completed in 1927. This replaced the gymnasium in the Carnegie Library. The Pioneer Gym was incorporated in the Scott M. Niswonger Commons, dedicated in 1999.

The Tusculum College Sports Center (Alpine Arena) was opened on January 17, 1998. The women's basketball team hosted Anderson College and the men's team hosted King College. The ceremonial first tip-off was thrown by Scott M. Niswonger (Class of 1987).

President Robert Knott is pictured with softball and volleyball coach J.C. "Red" Edmonds.

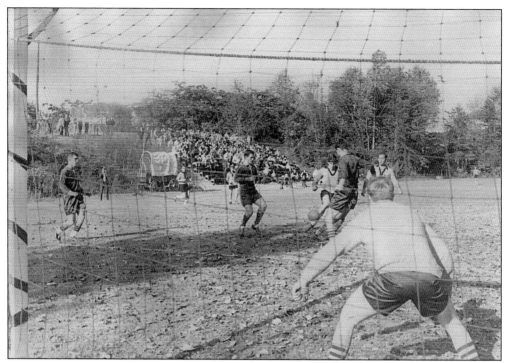

Soccer is a relatively new sport at Tusculum. The sport has enjoyed more winning seasons than any other male sport since World War II.

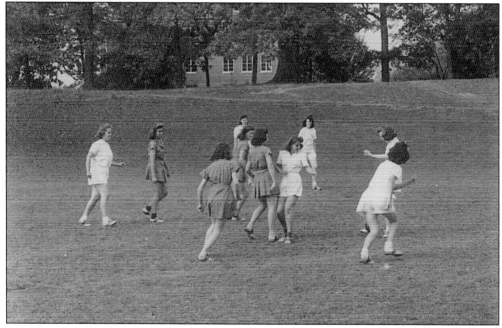

The Women's Athletic Association offered a variety of programs to women interested in sports. Participants were eligible for a sweater with a "T." Today, Tusculum offers a wide range of women's sports that compete within the South Atlantic Conference. This photograph was taken in the 1940s.

Roger M. Nichols, Class of 1950, is pictured here at the groundbreaking ceremony of the Roger M. Nichols Tennis Complex. The complex was dedicated on October 9, 1992.

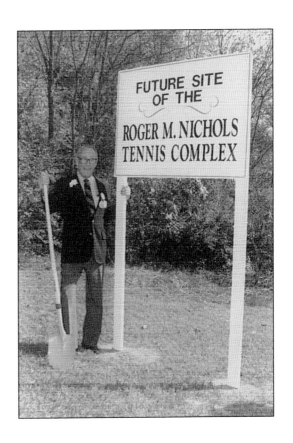

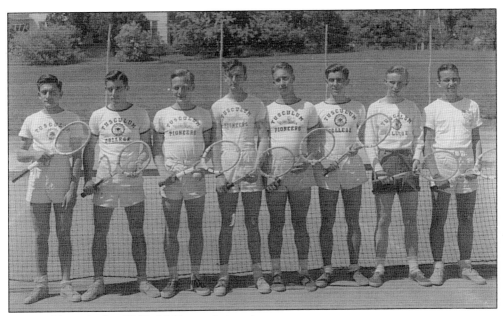

Pictured here is the 1940–1941 tennis team.

INDEX